PAINTING
Sumptuous
VEGETABLES, FRUITS & FLOWERS
in Oil

PAINTING
Sumptuous
VEGETABLES, FRUITS
& FLOWERS
in Oil

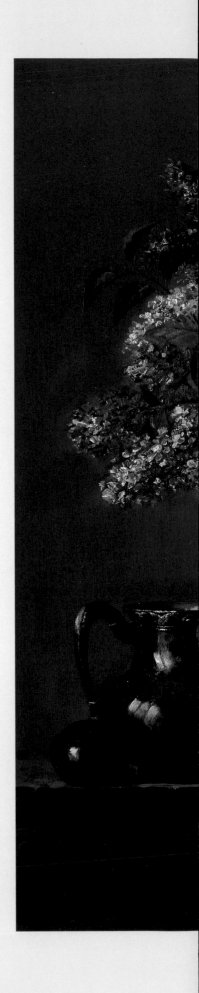

JOE ANNA ARNETT

NORTH LIGHT BOOKS
CINCINNATI, OHIO

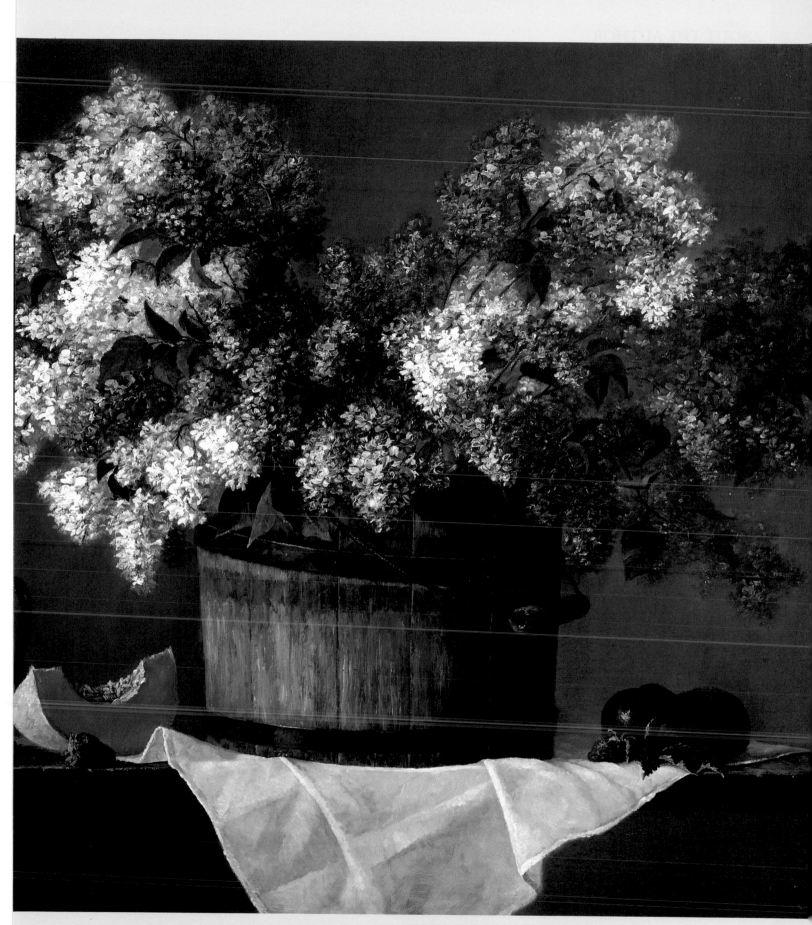

LILACS AND BLUE BUCKET II, 24″×29″ (60cm×74cm) Oil on linen

Contents

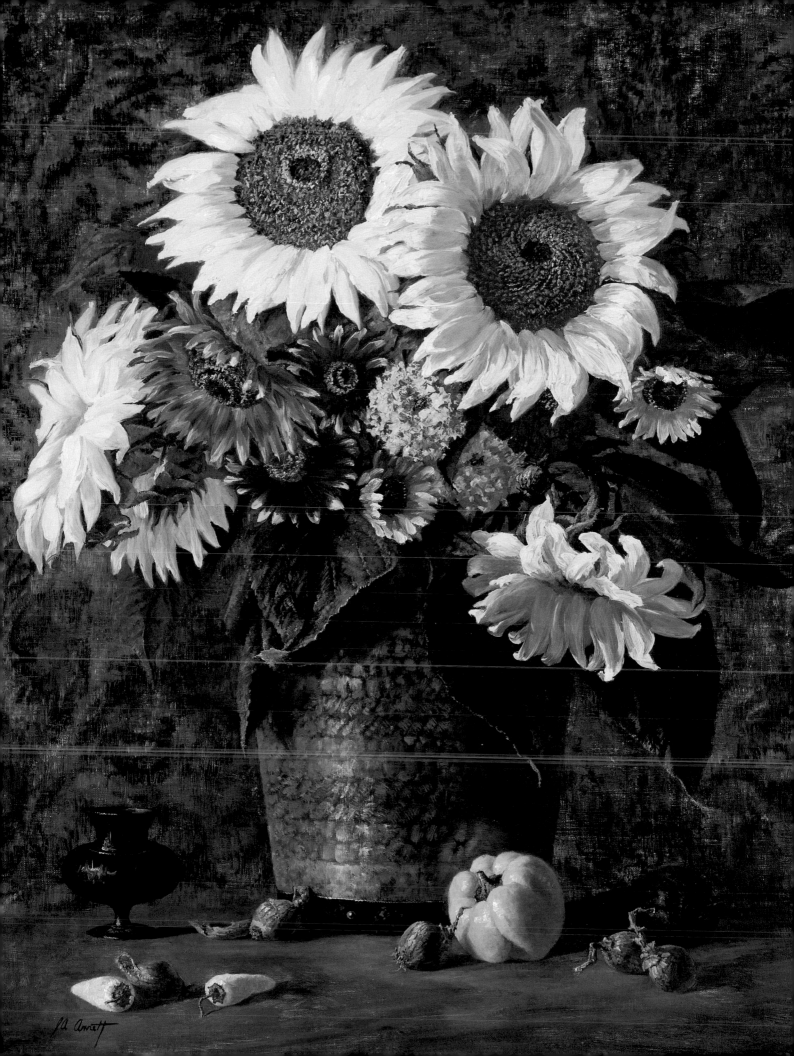

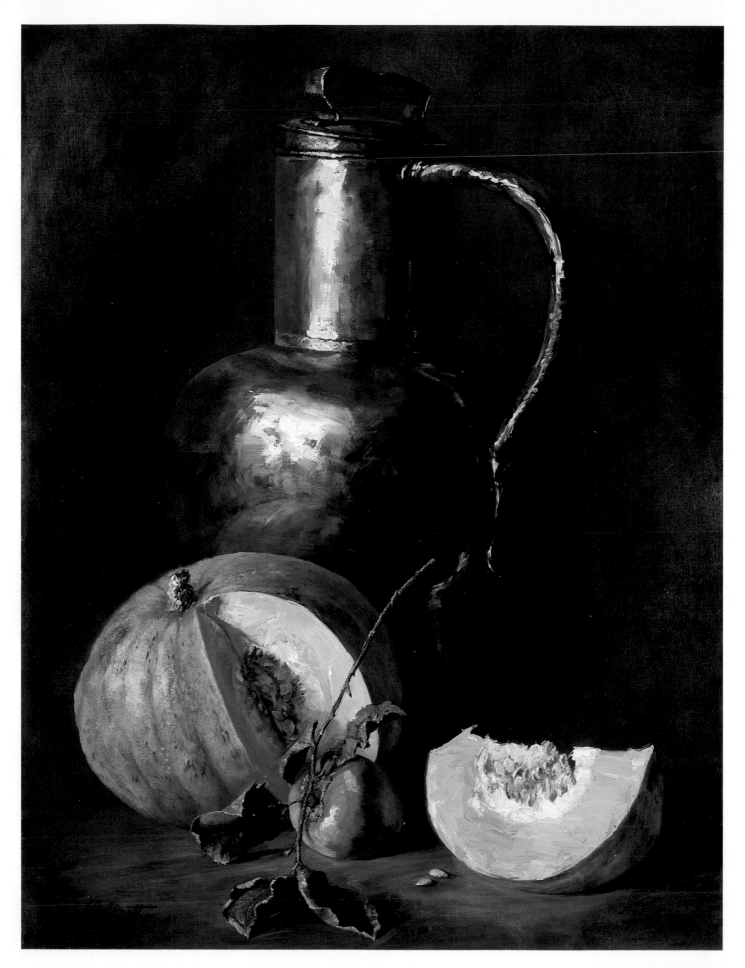

The Universe of Still Life

I love being a still life painter. It is a great joy for me to have the opportunity to share with you the things that life, gifted teachers and time have taught me. I would like you to experience the feelings I experience at the easel. There can be a rush of joy and power when you are in complete control of the small universe that is your still life canvas.

Life often seems like a freight train charging at full throttle with me hanging on for dear life. It all goes by so fast, and we are all pushed and pulled by forces out of our control. This is not so when you are standing before your canvas. Here you become director, producer and star maker. Here, only you set the pace and only you make the decisions. This small universe is yours and only yours. You even have the power to change nature if you wish. If altering the petals of a flower or the shape of a turnip suits your painting better than the way they grew, change them. If the color of a rose isn't in perfect harmony with the color world of your painting, change the color. I promise you, the rose won't mind.

You can experience this feeling of power and control for at least that part of your life while you are painting. There are some techniques, some tools and a few ideas presented here that will help you gain control and experience the freedom that control can bring. Some are illustrated here, and many you will discover on your own.

You will then put your brushes down for the day and the phone will ring, or you must open the mail and deal with it or rush to the grocery store. Life will hit you again. None of us can escape this reality check. But at least for a time you can live in that sweet, peaceful place that is painting.

YOUR PATH

The first step is difficult. It is, very simply, to begin. It is hard to know where to begin because there are so many different and valid ways to start. However, in a convincing still life painting, the most important thing to know is where you are going before you start. Your goal must be set first. What do you want your painting to say? What emotion do you want to create? And yet, even as you know your goal and have the clearest idea of your purpose, you must still start somewhere.

I wish I could show you everything on the first page so that you might come to understand all of the important principles immediately. I would like to help you see that it is as important to paint the big idea as it is to paint the smallest detail. The pumpkin and all the other elements in your still life must be in the right place on your canvas, painted with the proper knowledge and, in the end, must look like a pumpkin that you have just brought in from the field. It must not only have the proper color and shape, but also volume and gravity, and it must exist in an atmosphere of air and light. It must belong where you have placed it.

I want you to feel comfortable when you tackle some possibly intimidating forms; paint metal so it comes alive and glows out of the canvas; make your viewers feel like they are actually looking *through* glass; paint flowers with such conviction that you feel you might smell their fragrance. You will learn useful principles and techniques to help you along your individual road. Where you go is up to you, and that is as it should be. That is as it *must* be.

For decades, artists have learned many of the same basic principles, but have chosen to use them in their own ways. These are the artists we remember through the centuries. I urge you, if you get nothing else from this book, to believe that your path is just as important as the path of anyone else. You are the most important artist in your life.

GIVE YOURSELF TIME

I wish to begin by giving you some gifts. These are things you deserve and already own, but perhaps don't know you possess.

Among the questions most often asked by my students is, "What is the secret?" The student will say, "I know how to model form. I know about air and perspective. I've learned about edges and the power of the brush. What happens now?"

My answer is always the same—time. This is the most important gift I wish for you, and you must give it to yourself. Time is the most valuable, and also the most difficult, gift you owe yourself as an artist. There are always, and always will be, urgent demands upon your time. Some of you must hold down demanding full-time jobs. Children need you, and art may seem to always be the last thing on your agenda. You must learn to be demanding and find ways to give yourself the time you richly deserve. Structure can help, and a supportive family is a blessing. I cannot give you the answer, I can only tell you that you must—you will—find

THE GREAT PUMPKIN
27" × 20" (69cm × 51cm) Oil on linen
I found this unusual pumpkin at the farmers' market. The farmer didn't know its name, only that it was a hybrid of some sort. The outside was almost pink. He couldn't tell me the color of the meat because he had never cut one; he only grew it because he liked the color. When I cut it open, I couldn't believe my great fortune: I was staring at a vibrant golden yellow that delighted me. I painted a slice reflecting into a French skim milk can. The persimmon adds even more warmth, and its branch points back to the reflection of the pumpkin slice on the can. Light on the handle of the milk can and the curve of the persimmon branch add a serpentine flow to a composition that easily could have become static.

In the Beginning

O ne of the questions I am asked most frequently is, "How do you decide what to paint?" After so many years of painting, I find that I no longer pick my subjects: They pick me. It is a demand that I must answer. However, I didn't start that way. The journey took a while; every step was important and contributed to the next. In school, and for years afterward, I painted many subjects: portraits, figures and landscapes. I studied anatomy (and more anatomy) and perspective (linear and aerial). Then, slowly, I realized that I gained the most enjoyment from still life, from the wonderful variety of forms from nature. With still life, you have complete control. You decide what to put in and what to leave out. Take your own journey and explore many subjects.

PRIMARY TULIPS, 26″×22″ (66cm×56cm) Oil on linen
"Primary Tulips" is a painting that emphasizes the three primary colors: red, yellow and blue. I encourage you to treat yourself to the best pigments available, especially for your primaries. You won't regret it.

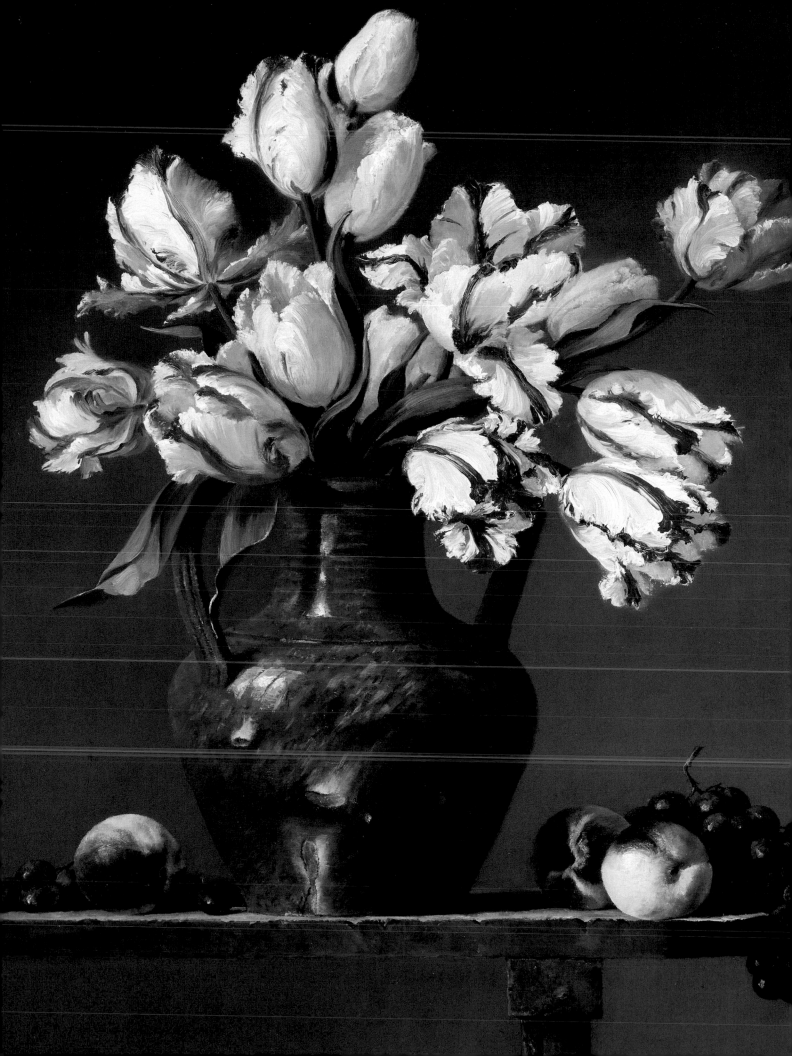

Subject Matters

The first step, of course, is to decide on your subject. One element for which there is no substitute when choosing a subject is passion. You must feel something for your subject. It will show if you do—and it will certainly show if you don't. If you are not entertained by what you are doing, you cannot expect to entertain anyone else. I have seen many artists who are wonderful craftsmen. They are well trained and technically superb. There is absolutely nothing you can find wrong with their work. Yet you get no feeling, no stirring of emotion. So what is wrong with this picture? Everything. You don't want to make a painting that just hangs nicely on the wall and doesn't clash with the furniture, do you? I certainly don't. I want to stir a feeling, evoke a memory, surprise, delight, or calm and comfort. I have to feel it first and then try my best to put it into the picture. If I can't do that, I am just a technician. There is nothing wrong with being a good technician. That is, after all, the real subject of this book. You must learn your skills and then apply them. But don't stop there. Go out to the markets; visit gardens, the farmers' market and the flea market. Try to decide what touches you. Paint it, but paint it with passion.

This photograph shows the blossoms of an African tulip tree in Hawaii. I fell in love with this tree the day we arrived and I was determined to paint the blossom as soon as possible.

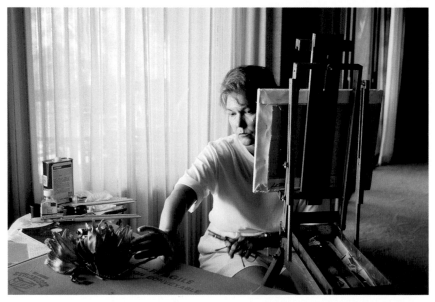

I set up a temporary studio in our rented condo, using overturned drawers from the dresser to hold my palette, paints, accessories and supplies. Always take plastic drop cloths along.

These are a few props I have collected. Much of the pottery is from France. I found Adriatic seashells in a shop on the wharf of a fishing village where we stopped for my husband to paint the colorful wooden boats. You never know where you might find props. Keep looking.

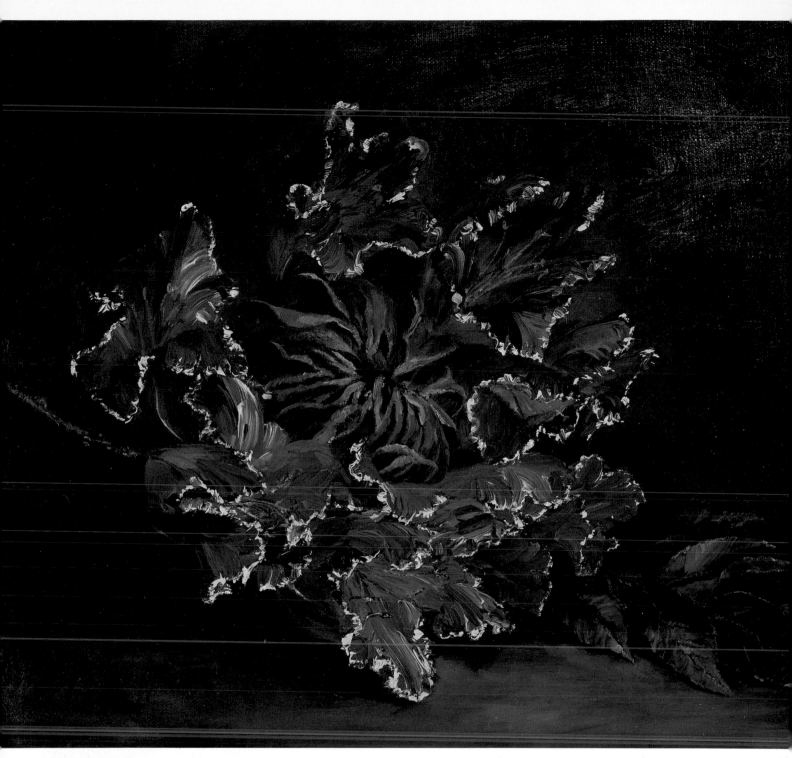

AFRICAN TULIP
14″×16″ (36cm×41cm) Oil on linen
This painting is of a single African tulip blossom. I was fascinated
by the form; one blossom seemed like a complete bouquet and the
color was so vibrant and inviting.

FIND YOUR INTERESTS

All you have to do is paint—and keep painting—and you will realize eventually that some things interest you more than others. These things will probably not be the same things that interest me. You can become an individual with superb technical skill and your own taste in subject matter. Subject matters, indeed, but it must be your very own and must stir *your* emotions. You will get there. Simply paint and paint—and paint some more. And give yourself that most precious of gifts—time.

My husband is a wonderful watercolor artist who paints landscapes, villages and markets, among other things. So we travel often, and sometimes teach where we travel. I taught in Italy one fall, and we went to Tuscany two weeks before my class started to relax a little and paint our own paintings. We rented an apartment in a restored monastery surrounded by hills and farms. As we drove up the dirt lane the first day, my subjects began to pick me and would not leave me alone. Directly across from where we parked our car was an ancient fig tree. The figs were ripe and bursting, revealing the pink meat inside. White gourds tumbled down the hillside in front of our apartment, and there were outrageous, deeply fluted tomatoes ripening on burdened vines. There were grape arbors with deep purple and pale green clusters of wine

TUSCAN FIGS, 7½″ × 8½″ (19cm × 22cm) Oil on linen mounted on Masonite
Here was a rare chance to paint figs the way I have seen them in some of the Dutch Master still lifes. When we find them in our grocery stores, they are perfect, no splits, no cracks, no leaves . . . no fun.

grapes hanging down, teasing me every time I walked under them. In the local market, mushrooms were sculptures in themselves. It was almost too much and I knew I wouldn't have time to get everything down, even considering the smaller canvases I usually bring on long trips. So we did the only natural thing: We began to plan our next trip.

You see, it really is true. After a time, your subject will find you.

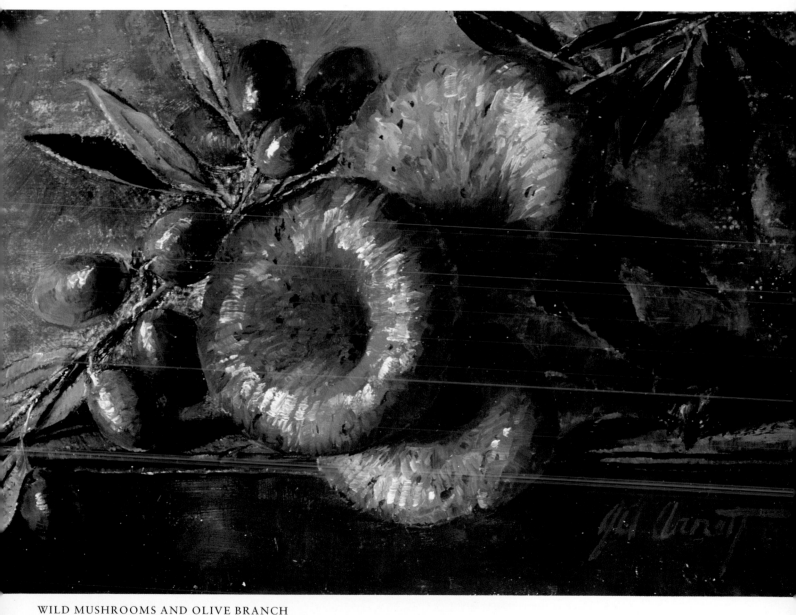

WILD MUSHROOMS AND OLIVE BRANCH
5″ × 7″ (13cm × 18cm) Oil on linen mounted on Masonite
I cut these mushrooms from an old tree stump near our apartment in Tuscany. I don't know if they were edible or not: We didn't take the chance. The olive branch with its silver leaves was a delight. We had arrived just before the harvest.

EGGPLANT AND ONIONS

7½″ × 11½″ (19cm × 29cm) Oil on linen mounted on Masonite

This six-sided shape was interesting to compose. The twisted, dried tops of the onions were perfect to help establish a powerful foreground by letting them exit the canvas both top and bottom. The eggplant was like none I had ever seen before. Originally, eggplants were white and shaped like eggs. This later relative remembered its origin and held on to some of the white.

From the terrace of the villa where I was teaching a class, we could see the rolling hills surrounding Florence. On a clear day we could also see the top of the Duomo (the dome of the Florence Cathedral). The temptation to include this view was impossible to resist.

The Right Tools and Materials

My father was an expert carpenter and contractor who built buildings to last. One of his favorite expressions was, "Half the job is having the right tool." He impressed upon me the importance of using exactly the right tools and materials and taking the very best care of them. Whether he was building a birdhouse or a bank, I never saw him use a dull saw blade. I think of him and this valuable lesson every morning when I look down at a well-organized palette with beautiful, vibrant pigments, reach for clean, responsive brushes and touch expertly prepared linen.

I give you the same advice that has worked so well for me. Use the finest materials available.

PAINT

My favorite brand of paint is Blockx. I use it because I feel it has more pigment and less extraneous materials than any other. These are the pigments I use most often and in the order I place them on the palette:

Naples Yellow
> (Holbein is now offering Naples Yellow in both French and Italian formulas. The French is a little pinker and the Italian is cooler. I prefer the Italian for still life and flower painting.)

Yellow Ochre
Cadmium Yellow Pale
> (Blockx is my favorite brand here. There is none so bright.)

Cadmium Red Orange
Cadmium Red
Manganese Blue
Cobalt Blue
Ultramarine Blue Deep
Raw Umber
Burnt Sienna Deep
Ivory Black
Rose Madder Deep
Flake White
> (This pigment contains lead, so be sure to follow safety precautions. Never ingest the paint, keep your hands clean and work in an area with proper ventilation.)

I occasionally add Cadmium Yellow Light (used along with the Cadmium Yellow Pale when I paint sunflowers), Permanent Rose (added to the palette for certain delicate old-fashioned roses and sometimes peonies) or Cobalt Violet (sometimes used for dark irises, and occasionally mixed with white when I want a silvery effect in the whites).

MEDIUMS

Maroger medium—This is commercially available by mail order. It is a gel that liquefies somewhat when touched with the brush and mixes easily with pigments. It contains a small quantity of varnish, which contributes to the transparency of shadow mixtures. Maroger has excellent drying properties. It sets up overnight and is dry enough to work over the next day, but not so dry as to create problems. When I am working on part of a canvas that has dried, I brush over the area I intend to work with a very thin coat of medium. This helps the new paint adhere to the old. If you choose to do this, be conservative. You don't want to add any more oil than is absolutely necessary. Maroger has no slick feeling and holds truly exciting brushstrokes. It does, however, contain lead, so be sure to keep your hands clean.

LeFranc & Bourgeois Medium Flemand—This is stiffer than Maroger, though drying properties are similar. Once you become accustomed to the stiffer feel and greater drag of the brush, you will enjoy the beautiful control this medium gives you. It too contains lead and must always be properly handled.

If you don't want to use a medium that contains lead, mix one part Damar varnish, one part linseed oil and one part turpentine. Carefully measure these ingredients into a baby food jar; cap it tightly and shake it vigorously each morning before using. This medium has nice liquidity, with good painting and drying qualities. It is definitely, however, my third preference. I have spoken with restorers and they prefer that artists use as little medium as possible. Blockx paints seldom require much additional medium to reach the consistency I like. I use it only to change consistency of paint, where I wish to have a more transparent quality or, occasionally, to help support impasto (very thick) brushwork.

BRUSHES

There are many wonderful brushes available. You will soon find your favorites, those that work best for you. I most often reach for:

Long filberts—Available in several brands, I like the Grumbacher Edgar Degas series 4229.

Softer filberts—For subjects that require a softer brush, I like the Raphael series 8792 Kaerell. These filberts work beautifully when you must blend or

occasionally underpaint. Use them for the final varnish as well.

Small round brush—For your signature.

PALETTE

The palette I use in the studio is made of Plexiglas with brown paper glued to the underside. This helps me judge values since it is the same value as the toned canvas I use to begin my paintings. When traveling, I use the wooden palette with my French half-box easel. Be sure to season a wooden palette by rubbing linseed oil thoroughly into the grain before you use it for the first time.

PALETTE KNIFE

Mine is of medium flexibility and not too sharp. I often use the very edge for delicate painting. For example, it is invaluable when I paint highlights on a thin branch. I also use it quite often when painting metals to place the highlights with greater bravura.

PAINTING SUPPORTS

I use linen prepared with rabbitskinglue sizing and primed with two thin coats of white lead paint. I usually prepare this myself, but there are some wonderful oil-primed canvases available commercially. For very small paintings and for traveling, I glue the primed canvas onto ⅛" (.32cm) Masonite.

FINAL VARNISH

I prefer Damar. Make sure your painting is completely dry before varnishing. I do not use a heavy coat of varnish, and sometimes even thin it a bit with turpentine.

PAPER TOWELS

I use paper towels to wipe my brushes during the day and to clean up at the end of the day. I probably go through a large roll every two days.

TURPENOID

I use Turpenoid for cleaning my brushes and palette. I do not use turpentine in my paint or even for cleanup. Adding turpentine really isn't necessary unless you are laying down thin washes, and this is not a technique I enjoy.

MATERIAL MAINTENANCE

Another favorite expression of my father's was "The job's not finished until your tools are clean and ready to use again." When you begin your work in the morning, you should not have to postpone painting because you must first clean up from the day before. You would be wasting that wonderful first flight of energy.

Scrape your palette clean at the end of each day, leaving only those pigments that dry *very* slowly. It is best to use fresh paint every day. Once the paint leaves the tube, it begins to dry, which can threaten the longevity of your painting. I also wipe the palette with Turpenoid and occasionally clean it thoroughly with 90 percent isopropyl alcohol, which can be purchased at any pharmacy.

Be sure to wipe your palette knife. This tool is only useful if the edge is sharp and the blade is still flexible.

Brushes need special attention. First wipe off any excess paint with a paper towel, then rinse them in Turpenoid. After that, wash them in mild soap and warm water, rubbing them gently against a bar of soap. Fels Naptha is a good choice. Continue this until the brush contains no paint residue. Gently reshape the wet brushes and lay them flat to dry. Brushes left standing will allow water to drain down into the ferrule, which will weaken the structure of the brush.

This photograph of my palette shows the order I prefer for my pigments. I always use the same order. This saves valuable time. I never have to search my palette for the color I want. I reach automatically for the right pigment. Eventually, this will become automatic for you too.

When this photograph was taken, I was painting a white flower with deep rose stripes (below). Note that the colors are not overmixed. Letting the parent colors of the mixture show in the painting adds excitement and lets the eye of the viewer do some of the mixing.

PARROT TULIPS AND TAPESTRY, detail
22" × 26" (56cm × 66cm) Oil on linen

Begin With the Big Idea

In the beginning there must be a big idea. It should be strong but flexible. Know where you are going, but accept a better solution if one comes to you. The very start is where you should spend the most time asking yourself questions, checking the strength of your idea and the validity of your goal.

SET UP YOUR COMPOSITION
Working only from life always translates into a freshness. The real object, changing and decaying right in front of you, creates an urgency that gives energy to the painting.

Your setup should already look like a painting. Spend time here. It is very important. Move subjects around. Add. Subtract. Look at your setup from different angles. The more interesting the setup, the more successful the painting.

A SINGLE LIGHT SOURCE
My choice is the same one artists have made for centuries . . . a north-facing window. North light gives you consistent light all day long, and you are never interrupted by shifting light. I also like its cool color. My studio walls are a soft, neutral gray with a soft texture that eliminates the problems of bouncing light and shifting colors.

Yet working by daylight may not be an option for you. If you must work by artificial light, use a daylight-corrected spotlight to light your subject. Lower the remaining lights in the room to reduce lights from other sources shining onto your setup and confusing the form.

THE FIRST STROKE
I like to begin on toned canvas. I use Burnt Sienna and Ultramarine Blue mixed with a little medium and brush this on loosely. I wipe it down with, of all things, worn-out nylon stockings; they leave no fibers or lint behind. Wear gloves when doing this because some of the mediums I have recommended do contain lead.

THE BIG SHAPE
It is a great help to first establish the big shape of your entire composition. In "Eggplants, Pepper and Onions," the overall shape of the composition is a strong triangle. This step helps locate the painting on the canvas. You may, at this early stage, decide on a bigger or smaller canvas, a different shape of canvas or altering your composition slightly. Are the composition and canvas going to live comfortably together? Look at your setup. Stare at your canvas and try to imagine the painting already there. At this point, you are looking only at an abstract shape and determining if it works. Later, you will be looking at beautiful colors and bravura brushwork. The decision to change something becomes much harder to make.

SOLIDIFYING FORMS
While still working on the big shape, give it greater definition and lay in your shadows. I find it helpful to think of shadows as the skeleton upon which I will build the painting. These powerful shapes will help you determine very early whether or not this is to be a strong painting. I often paint the shadows all in one color—a warm dark. You want to see the shapes and how they will relate to each other. You will refine the color and add all the delicious nuances later.

THE SMALL FORMS
When painting the very small forms, follow the same steps used in painting the bigger forms. First, paint in the shadow of even the tiniest of forms.

Then lay lights on top. Think of it more as *stacking* the lights on rather than painting them on. Don't be afraid to use paint boldly in the light. In "Eggplants, Pepper and Onions," the onion tops have wonderful textures. Use them. Interesting textures bring shapes forward. Perhaps a more artistic way to state this principle is "Impasto comes forward." *Impasto* is simply that very beautiful word we use for "thick paint."

STAND BACK
How many people does it take to paint a masterpiece? Two. One to paint it and another to hit him over the head when it is finished. The toughest decision of all is deciding when a painting is finished. Countless paintings have been ruined by not stepping back and making this decision at the right time. It is just as easy to "overpaint" a piece as to "underpaint" it. Ask questions. Did I stay true to the original idea? Is the abstract form as strong now as it was in the beginning? Are the values correct, the colors strong enough and the drawing precise? Did I get carried away with the details? Leave—literally walk away. Return with a fresh eye, unafraid to see the truth.

Self-criticism is more valuable than any you may receive from others. Only you know what your goal was and only you know if you reached it.

This point is *very* important. Learn your skills. Give yourself time to mature and find out about the individual artist you are. *Do* listen to qualified, well-trained people. Go to museums and study great art. Let it seep into you and become a part of you. Study. Learn. Work hard. Spend time alone with your work and decide if you have made a true and honest statement. Decide if you have made an *original* statement.

Toned Canvas

1. The Big Shape

The strong triangle here is comfortably situated and suits the shape and size of the canvas.

A Strong Foundation

One of my father's expressions was, "A building is only as strong as its foundation." Build a strong foundation and everything you do to the painting from beginning to end will have a stronger impact.

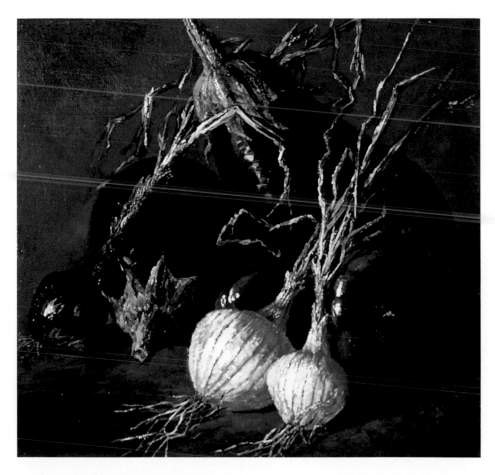

2. Solidifying Forms

I have fit my entire painting dramatically onto the canvas and have laid in the strong skeleton of the shadow shapes.

Build shadow and solidify forms. Define the drawing more and begin to build color. These onions will be bright white in the final painting, so I lay in their shadows brighter to start. Don't get tight. It's too soon.

Continue to define shapes, painting the eggplants and red onion as dark silhouettes. The shadows and red of the pepper go in. The white onions can now be modeled.

3. The Small Forms

First paint in shadows of onion tops, then stack the lights on top. Use thicker paint for the lights. I look closely at the colors and decide if I have chosen correctly. The pepper is red, of course, but also contains some orange. The highlight is bright white. The surface of this kind of pepper is shiny and tends to reflect light rather than disperse it. The white onions in the foreground are not pure white at all, but contain a range of greens; the ribs have some Raw Umber and Burnt Sienna. Place strong highlights on all of the forms. These are all cool whites and should be done with strong and energetic brushstrokes. The white highlights on the onions are almost pure pigment. You can cool these highlights even more by adding a tiny amount of Cobalt Blue.

Finally, it's time to paint the details. I've been waiting for this. The twists and turns of the onion tops are great fun to design and add so much interest and movement to the painting.

EGGPLANTS, PEPPER AND ONIONS
7½″ × 7½″ (19cm × 19cm) Oil on linen mounted on Masonite

1. Setup

This photograph of the setup for "Crusader Sunflowers" looked great to me in the beginning. In fact, I painted the flowers in almost exactly this arrangement.

2. Big Shapes

This initial lay-in looks much like the original setup. Sunflowers don't last very long, so you must get them down quickly. After finishing the important sunflowers, I had to put this painting away for a while to complete a commission for a client who had an anniversary deadline.

CRUSADER SUNFLOWERS
29″ × 24¼″ (74cm × 62cm) Oil on linen

3. Final Adjustments

When I returned to the painting, I had some problems with the composition of the elements on the table. I had initially placed the melon slice on the left, with the light just glancing across it, to serve as an entrance into the painting. While this still felt like a good idea, after I had finished the sunflowers, the painting had such a powerful left-to-right movement that it seemed to want a strong ending on the right . . . something more powerful than my original thought. The angle of the now fully lit melon slice points back up into the composition. The red crab apples echo the red zinnias hiding amid the sunflowers.

Why the unusual title? Look at the background again. The tapestry is of Renaissance knights.

1. The Big Shape

The first step for "Summer Roses" already shows the shape and location of the entire painting on the canvas. It is very loose and full of promise. Already, the cascading shape of the roses is evident.

2. Roses

For variety and availability, we grow over thirty-five varieties of Heritage roses in our own garden. The old roses, once cut, have a very short life. This is why you won't find them in the florist shops. Because I had such a short time to work with them, in step two of this painting I chose to paint all of the roses in a very finished form. Leaves and buds last longer, so I waited a while on these. Still, the strong triangular shape of the composition holds firm. All of the shadows of the roses were painted with relatively thin paint. The light sides of the roses were painted with thicker paint . . . more impasto. The roses in the foreground were painted with even more impasto in the light and with crisper edges and bolder brushwork. This helped to bring them forward.

3. *Critical Analysis*

Branches, leaves and buds were added to create depth and to make the shape of the bouquet more varied and interesting. The old brass teapot was just the right color to harmonize with the yellow, apricot and deep pink roses.

Tiny apricots reflecting into brass echo colors in the flowers.

SUMMER ROSES
12½″ × 15″ (32cm × 38cm) Oil on linen

Color: A Theory of Relativity

I make time to teach once or twice a year for several reasons. Many gifted artists took the time to give to me, just as their teachers and their teachers before them had done. I feel part of a tradition when I am teaching. I am passing on what was given to me, adding my own voice to it, and I might even be helping someone find the way to a fulfilling career—or at least to find pleasure in the painting process.

When I first began teaching, this reasoning sounded right and noble to me. Then I discovered something very interesting. I was the one learning the most in class. I have had a few students over the years who would not accept a simple explanation. They challenged and probed and forced me to come up with better, clearer answers. There were things that I had accepted in school without thinking about them very much. I just did them and went on. I forced myself to go back and think deeply about some of the things I had simply accepted as truth without challenge. This is one of the best things that has ever happened to me. One of these challenging concepts concerns a beautiful theory about color and the temperature of lights and shadows.

WARM SHADOW, COOL LIGHT

The theory of light and shadow that I have chosen to follow is quite simple. It states that shadows are warm, transparent and thinly painted. (Warm colors are usually those in which red, orange and yellow predominate.) Lights are cool, opaque and painted more thickly. (Cool colors are usually those in which blue, green or violet predominate.)

Please remember that this is a discussion of color temperature for the still life painter working in the studio. Landscape artists have other factors to consider and their problems and theories differ significantly from the information presented here.

STUDY THE MASTERS

This theory is a very old one. Study the paintings of Peter Paul Rubens (Flemish) and the amazing Dutch still life painters Willem Kalf, Pieter Claesz and Jan Davidsz de Heem. These are a few of my greatest heroes. You will see in their works some of the best examples of this theory. You will also see delightful images that will inspire you and enrich your life. If you get the chance to look at any of their paintings in person, run, don't walk. You will see the warm shadow, cool light theory in action. If you can't get to the museums, there are wonderful books with examples of these masters and many others.

It is to these masters that I return for review of the warm shadow, cool light theory. If you think that my work has a hint of an "Old World look," this theory is the reason.

THEORY OR FACT?

Put ten professional artists in a room, pose this question and then get out of harm's way quickly. Each will swear to a different theory and know for certain that all the others are wrong, or at least misguided. I truly do see shadow as warm and light as cool in my north-lit studio. There are artists I respect very much who do not see it this way. I have demonstrated my observations about color temperature in the studio to some of my students and they see it as I do. Other students will look at the subject and say, "I just don't see it. It just doesn't look that way to me." I don't force them. That would be wrong. They

either see it or they don't; if they don't, I try to help them create convincing form their own way. There are artists who rebelled against this theory such as Edgar Degas, Claude Monet, Paul Cezanne and Pierre-Auguste Renoir, to mention only a few. I will not attempt to compare all the different theories about the temperature of light and shadow: that is a subject for an entire book. I will only tell you that the warm shadow, cool light theory is one that has served me well and has delighted me for a long time. I like the look of tradition that it implies, and I believe that it helps to create a convincing and exciting painting.

Once you have painted for a while using this theory, you will begin to solve a lot of problems on your own. Until then, I would like to help you over some stumbling blocks my students experience when they first begin to use this idea.

Books and Museums

Wherever my husband and I travel, we always make our first stops at the museums, and then move on to the bookstores. The library we have built over the years is one of our greatest treasures. When I am confused or just out of gas, I surround myself with some of my favorite books in the middle of the library floor. I visit with my heroes and soon feel better—ready to tackle the canvas once again, refreshed. I recommend this therapy to you. It is amazing how you can feel simultaneously humbled and inspired.

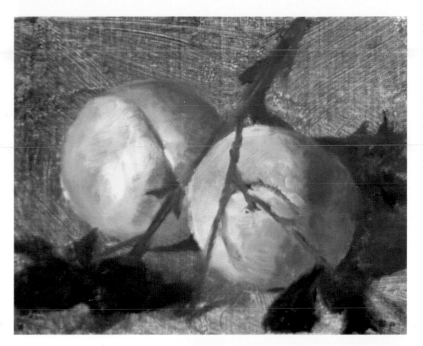

1. Lay-In

This painting is so small that I did the lay-in a little differently than usual. I painted the shadow shapes plus the beginning of the local, or actual, color of the subject at the same time. The local color of yellow peaches is already a warm color, a mixture of Naples Yellow, Cadmium Yellow Pale and white. It is, however, cool next to the much warmer yellow of the shadow mixture.

2. Shadows and Highlights

How do you make the shadows warm and the lights cool when the local color of the subject is already warm? The shadows should be warm *relative to* the temperature of the lights. Yellow will always be a warm color, whether it is the comparatively cool yellow of a peach or the much warmer yellow of a nectarine or a lemon. By painting the shadows *warmer* than the lights, whatever their local color, this visual language still works.

The shadow color is a mixture of Cadmium Yellow Pale, Ivory Black and a little Cadmium Red Orange. These peaches are basically spheres, and the edges of all forms become lighter as they turn away into space (see p. 49). This is because there is a small amount of light reflecting back into the form from the shadow side. This is called *reflected light* and it helps the form turn and seem more three-dimensional. The reflected light on the shadow side of the peaches was created by eliminating a little of the black and red-orange and letting the remaining yellow lighten the far edges.

The fuzz on the peaches was done with a simple mixture of Ivory Black and white. The highlights, which were softly painted on the light-dispersing surface of the peaches, were also done with this silvery black-and-white mixture.

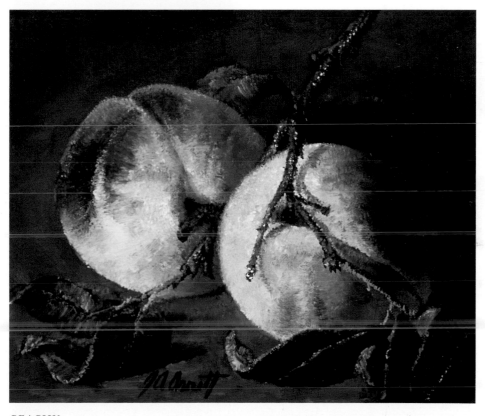

PEACHY
5″×7″ (13cm×18cm) Oil on linen mounted on Masonite

One Certain Rule

I am absolutely certain about one rule concerning painting: There is an exception to every rule.

WHAT ABOUT LOCAL COLOR?

One difficulty seems to be how the preceding theory affects the local, or actual, color of an object. You cool a color that is by nature warm to create a convincing light and warm a color that is by nature cool to create a convincing shadow. If you paint a sunflower or grapefruit, the local color is warm. If you are painting a lilac or blue vase, the local color is cool.

This is where we bump into the "relativity" part of the theory. Paint the light side of a sunflower in a yellow that is cool *relative to* the warm yellow of its shadow. Paint the shadow of a blue object in a blue that is warm *relative to* the cool blue of the light side.

Color temperature can be determined by environment; where a color is on the canvas. A green in one painting may appear cool if it is near a warmer green. That same green in a different painting may seem warm if it is near a very cool green.

Choose an object that has warm local color. Practice mixing to cool a warm color, as well as to warm it further. To cool a warm color, do not reach automatically for the white. When I cool red, I never reach for white. This creates pink—I want a cooler red. I often use Naples Yellow to lift the value and cool the red. This doesn't make it an orange. Naples is a dull yellow and is not bright enough to overpower the red. To warm the red, I may choose to add Rose Madder Deep or Alizarin Crimson. This darkens the mixture and creates a convincing shadow. Try these suggestions. You will find yourself painting apples, cherries, pomegranates and many other bright red objects in an exciting and believable manner.

When the local color is cool, the process is the same. A Cobalt Blue vase may need only a little red (either Alizarin Crimson or Rose Madder Deep) to warm the blue on the shadow side. The blue is already so cool on the light side that you may not need to add anything at all to cool it. The highlight could be white with a bit of Cobalt Blue.

1. Lay-In

A client commissioned *Sunflowers for Nicky* for his wife's birthday. The painting was to be relatively small, only 14″×16″ (36cm×41cm). The danger from the very start was having the painting look crowded.

I solved the compositional problem by placing the emphasis on just one heroic sunflower, with everything else playing very minor roles.

2. Defining Forms

In this step, I continued defining the forms and painted in a simple, solid background to help me get a better feeling for the space. I painted the sunflowers all in their shadow color, the warmest and darkest of all the yellows in the painting. I used Cadmium Yellow Light, Cadmium Red Orange and a little black for this mixture. I also painted the shadow shapes of the other flowers, then designed and painted in the important shadow shapes of the leaves and blocked in the simple brass bucket.

3. Light and Halftones

Having completed all of the shadow shapes, I began to paint the lights. Because the hero sunflower is the key to the success of the entire painting, I painted it first. Shadow colors were already there and still wet, so I had the opportunity to use that wet paint underneath and allow some of the color mixing to happen on the canvas, painting wet-into-wet. Do not try to make corrections when some of the still-wet shadow color shows through.

For all the places where light strikes this sunflower, I modeled the petals in Cadmium Yellow Light, using thick paint. This hero sunflower is farthest forward in the composition. The degree of impasto (thick paint) I used here was extreme, painted on with energy and extravagant brushstrokes. This flower had to be the most exciting, most luscious place on the canvas.

Halftones are those places where the light and shadow meet. With the sunflower, it isn't necessary to worry too much about the halftones because of the very nature of its form. Having used the wet-into-wet technique, I dragged the light and shadow edges together with the brush, mixing the tiny halftones of the petals right on the canvas. Halftones are more of a problem and must be handled differently when painting forms that have a smooth, slow-turning surface, such as a large vase.

The shadow side of the flower has reflected light. This light, reflected back into the shadow, is still warm but lighter in value than the shadow value. These reflections are very subtle, and I recommend using them sparingly. It is very important not to let them confuse the form.

The highlights were painted in pure, thick Cadmium Yellow Pale. Highlights are placed at those points that are directly opposite the source of the light illuminating the subject. They were painted in heavy impasto, with bold strokes. The Cadmium Yellow Pale painted on top of the Cadmium Yellow Light looks cool, and there is no need to add white to cool these highlights further. You will be amazed at how this thick, pure pigment will make the flower sparkle and come to life.

The remaining sunflowers were handled the same way, with slightly less contrast and impasto because they live further back in the picture plane. The lights and highlights were placed on the other flowers in the composition, and the brass bucket was finished with a glittering highlight.

SUNFLOWERS FOR NICKY
14″ × 16″ (36cm × 41cm) Oil on linen

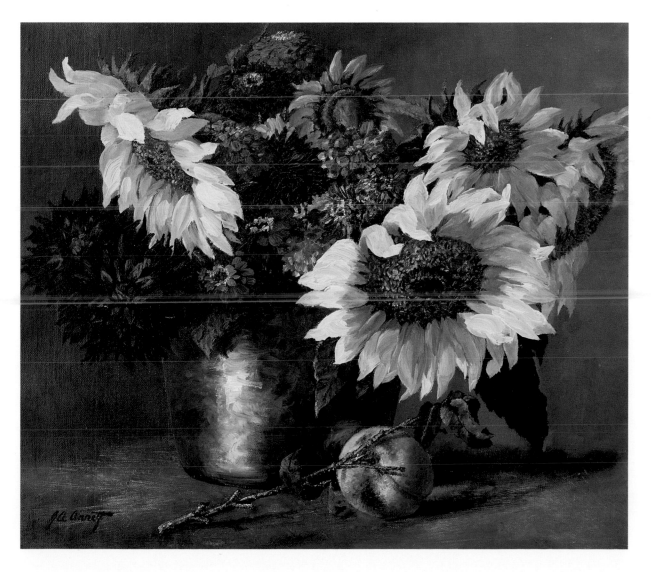

Painting Black and White

Black and white are some of the most important and difficult of all colors to manage. It's easy to get tripped up when using the warm shadow, cool light theory.

I consider both black and white to be generally cool by nature. This is another point where many artists disagree. I consider them cool because that is how they *act* in my paintings.

BLACK

Black shadows are relatively easy to warm simply by adding a red. Cadmium Red, Cadmium Red Orange, Rose Madder Deep or Alizarin Crimson will all warm and deepen the value of black, creating a dramatic shadow color for a black surface. If this mixture seems too red to you, you can easily neutralize it by the addition of just a bit of Ultramarine Blue.

Cooling black in the light is a bit more difficult. It seems natural to reach for white. Don't. White mixed with black will create gray. So, instead of painting cool light on a black object, you are now painting a gray object. Try cooling the black with one of your blues or with Raw Umber instead. The black will still overpower the other color, but will now appear cooler. Don't worry too much about trying to lift the value of the light side of a black object. Black is a color that wants to remain at a very deep value. Making simple temperature changes can be a powerful tool for you. For the highlight, you have several choices, depending on the specific nature of the black object you are painting. Pure white, white mixed with blue, or even white with a little black will create a convincing highlight.

WHITE

Warming and cooling white can be a confusing problem. I have worked diligently to take the mystery out of white because I particularly enjoy painting white flowers and do not want them to shift toward orange or blue or brown, the most common pitfalls. I want them to be glowing white flowers, beautifully and convincingly modeled.

For the shadow side of a white object, I most often employ a combination of Yellow Ochre and Ultramarine Blue, occasionally adding Cobalt Violet. The Violet is a *rare* addition for me, but I sometimes do it when I want to further dull the muted green created by the Ochre and Blue. Do this with great delicacy if you choose to do it at all, because the violet can quickly change your mixture to an uninteresting gray instead of the warm shadow you are working toward. The shadow of white is one of the very few shadow mixtures to which I add white pigment. Adding white to other shadow colors can create a chalky look within the painting and can destroy the transparent illusion of the shadows.

For the light side of a white object, you have a very important decision to make before you even begin to mix color. Stop and look closely at the white you are painting: Study the colors it contains. What color of white is it? The brilliant green-white of an early spring flower? Is it the warm, creamy white of a magnolia or a glass of milk? The aged white of a glazed antique vase? Seldom is white just white. It can be one of the most exciting colors to paint, but you must understand that white contains a lot of color. Don't be afraid to add color to white, and don't overmix the colors you choose to add. Allowing the mixture to reveal the parent colors and allowing some of the mixing to happen on the canvas are both very exciting and add extra drama to your painting.

For a bright spring white, experiment with this mixture: Mix a bright green using Manganese Blue and Cadmium Yellow Pale. Add just a breath of this to your white and you will create a very exciting, very bright white. By handling white this way, you have reserved your pure white for the highlight. To make a freezing white highlight, you may even want to add a touch of Cobalt Blue.

For creamier whites, such as a magnolia or an antique white vase, add just a touch of Naples Yellow to the white. This, too, lets you save your pure white for the very cold highlights. There are dozens of other whites: silver whites, violet whites, blue whites and many more. Some white surfaces reflect light and some disperse light. No matter what the color of the white you are mixing, remember that it must be cooler on the light side than on the shadow side, and that the highlight must be extremely cool.

DOGWOOD IN CHINESE VASE
25″ × 19″ (64cm × 48cm) Oil on linen
The dogwood blossoms are pure white. Their shadow is a mix of Yellow Ochre and Ultramarine Blue Deep with white. These colors are not overmixed. The color of the blossoms as they face the light is white plus a tiny amount of a green made with Manganese Blue and Cadmium Yellow Pale. The light was painted in heavy impasto for the foreground blossoms, with the impasto decreasing as the blossoms recede into the picture plane. Highlights on the blossoms were painted in even heavier impasto with pure white, employing vigorous brushstrokes.

The tiny foreground vase has aged a warmer white than the dogwood. The shadow mixture is the same as for the blossoms. The light side of the vase is white plus Naples Yellow. The highlight is pure white painted with a quick impasto stroke.

The large vase is a dark brown with red added to the shadow to warm it. The pattern on the vase is a very casual black glaze. Rose Madder Deep has been added to the black pattern on the shadow side to warm it. The black pattern on the light side is pure Ivory Black. The highlight on this glazed vase is pure white painted in a stacatto manner to help define the surface of the vase.

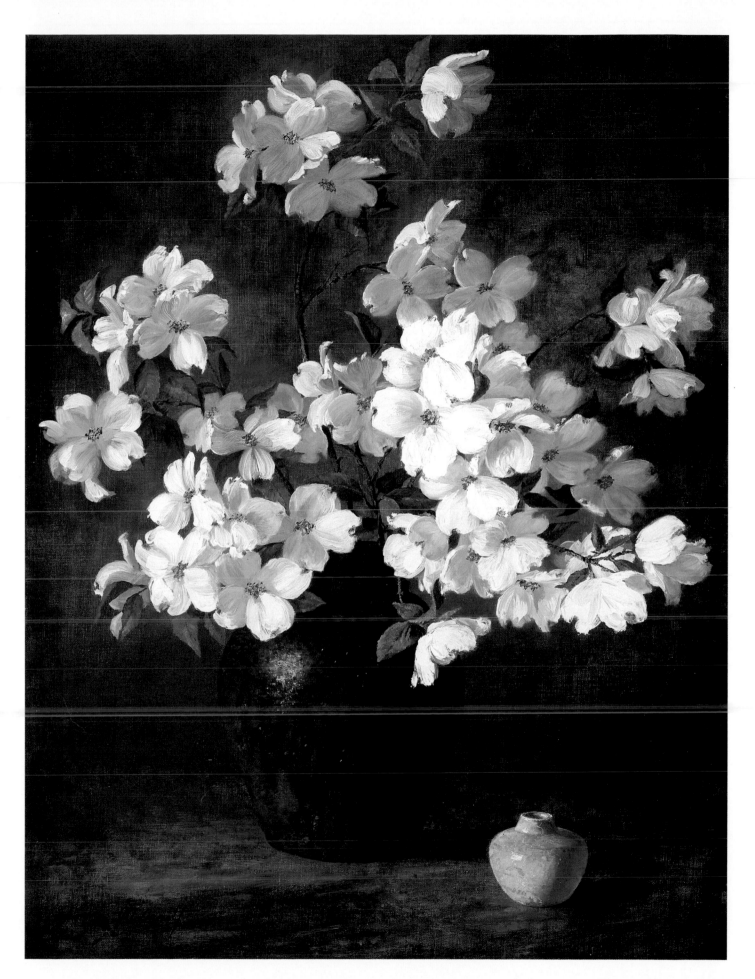

Aerial Perspective

There is an extraordinary misconception floating around that aerial perspective is the sole property of the landscape artist. Wrong. All artists who paint in the realist tradition should understand and learn to deal with the principles of aerial perspective. It is simply a way of thinking that helps us understand how air (atmosphere) affects what we see. This powerful idea helps create the illusion of three dimensions on a two-dimensional surface.

No matter how close or distant objects are from each other, there is air between them—and between you and your subject. Whether you are painting two peaches, one just in front of the other, or a distant hillside behind them, you must still paint the air in between. You can't paint the air, but you *can* paint the effect it has on the subject—and that will create the illusion of air.

A technique for painting aerial perspective most often explained by art teachers is to add blues, grays or violets to distant planes. While this certainly works, I prefer to think of the things that distance *takes away* rather than what distance adds. This path just seems clearer and simpler to me, especially when painting still life, where the planes are only inches apart. I have a litany of effects and go down this list with every painting I do.

DISTANCE STEALS WARMTH
Warm colors (yellows, oranges and reds) are stolen first by distance, leaving the cooler colors behind. This is easy to understand when looking at a distant mountain, but may be a bit difficult to see when objects are only inches apart.

The principle, however, holds true in still life painting. Working with inches instead of miles, you must remember to be very subtle with this point. The converse of this point, of course, is that warm colors come forward.

DISTANCE STEALS PURE COLOR
The further back an object is, the duller its color will become. Atmosphere, those layers of air and particles, steals the color. The brighter or purer a color is, the more it will tend to come forward.

DISTANCE STEALS VALUES
Distance reduces the number of values available for you to work with. Travel far enough back into the picture plane and objects will become one single value. A distant mountain may appear solid blue or gray. In the case of one lilac in front of another within the space of a few inches, this phenomenon is hard to see. It is subtle, but it is there.

DISTANCE STEALS CONTRAST
Contrast is the difference between light and dark. Distance steals this difference. Objects in the foreground will have sharper contrast between their lights and darks than objects further back. Save your sharpest contrasts for the nearest plane.

DISTANCE STEALS DETAILS
The greater the distance, the less detail you will see. This idea is closely related to the ideas about the loss of values and contrast. If you are standing in an orchard, you can see fruit, branches and leaves on the tree next to you. As you look down the row, you see less and less, until the trees lose all detail and become simple shapes. This is true in a still life painting also, even though we are dealing with much less distance. Look at the two yellow marigolds at the far left of "Zinnias, Sunflowers, and

LILACS, PARROT TULIPS, AND TAPESTRY, 24″×28″ (61cm×71cm) Oil on linen
The foreground lilacs have more contrast, harder edges, detail and texture than those further back. These changes are key to understanding and using aerial perspective.

Marigolds." One is painted just in front of the other. The marigold in front has details of petals; the one behind has petals that are only suggested.

DISTANCE STEALS SHARP EDGES

Edges of objects become softer the further back they are in the picture plane. This is a powerful technique for all artists, but is especially useful to the still life artist. The difference in the edges must be very subtle. However, even the slightest change in an edge can help you create the illusion of distance.

Conversely, sharp edges come forward. Save them for the extreme foreground.

DISTANCE STEALS TEXTURE

A background tapestry will be more convincing if it has less texture than one painted in the foreground. By reducing the texture, or surface interest of an object, you will help it recede.

Another very simple way to think of this is that distance steals paint. Impasto comes forward; thinner paint recedes.

DISTANCE STEALS SIZE

Objects in the distance appear smaller than their actual size. This idea relates more to linear perspective, but it is still an important point to remember when you are determining the size of objects in your painting.

ZINNIAS, SUNFLOWERS, AND MARIGOLDS
24½″ × 29¼″ (62cm × 74cm) Oil on linen
The foreground and background tapestry in this painting is the same piece of fabric. The background recedes because the values and contrasts, or difference between the lights and darks in the pattern, have been pushed closer together, and it has been painted just a bit lighter overall than the foreground fabric. That portion of the tapestry which comes forward and hangs over the edge of the table was painted with more paint (heavier impasto), crisper details, more pure color and greater contrast in the pattern.

Background Reference

I selected this landscape with a romantic castle ruin in France for the background of my painting because of its shapes and colors. The castle was isolated on a hilltop and created a simple, interesting shape against the sky. It was not, however, interesting enough to take too much attention from the foreground. The landscape was arid and rocky, and the values were already very close together. Distance steals contrast and color. This landscape already had little color and low contrasts; by its very nature, it expressed properties important to help create the illusion of distance.

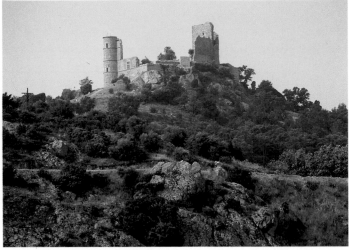

1. Establish the Big Shapes

Establish the big shapes of the entire composition. The flowers, vase and the other objects were treated almost as one shape. The landscape in the background was treated as a single shape also. By handling it this way, I knew very early how these large shapes would relate. At this point, I also established the major values. Dramatic darks and extreme contrasts remain in the foreground. Pure colors, sharp edges and details will be lost further back in the painting.

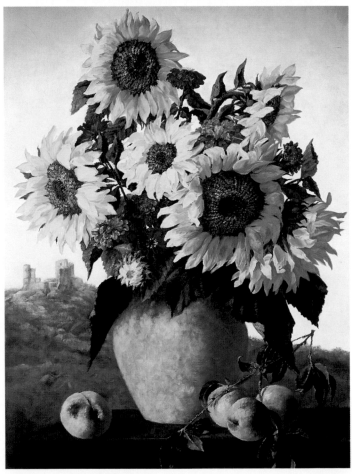

2. Consider Aerial Perspective

I was considering aerial perspective at the beginning of this setup. The arrangement of the peaches was not random. I selected the peach that is closest in the picture plane specifically because of its pattern. This peach had more color, more detail and greater contrast than the others. The branch and leaves came forward over the edge of the table and were painted with sharp edges and detail. These are things that will automatically come forward in the picture plane. Let nature work *with* you from the start.

Once cut, sunflowers have a short life, so I finished them as soon as I had established the composition. The zinnias and peaches were painted next, while refining the shape of the overall composition.

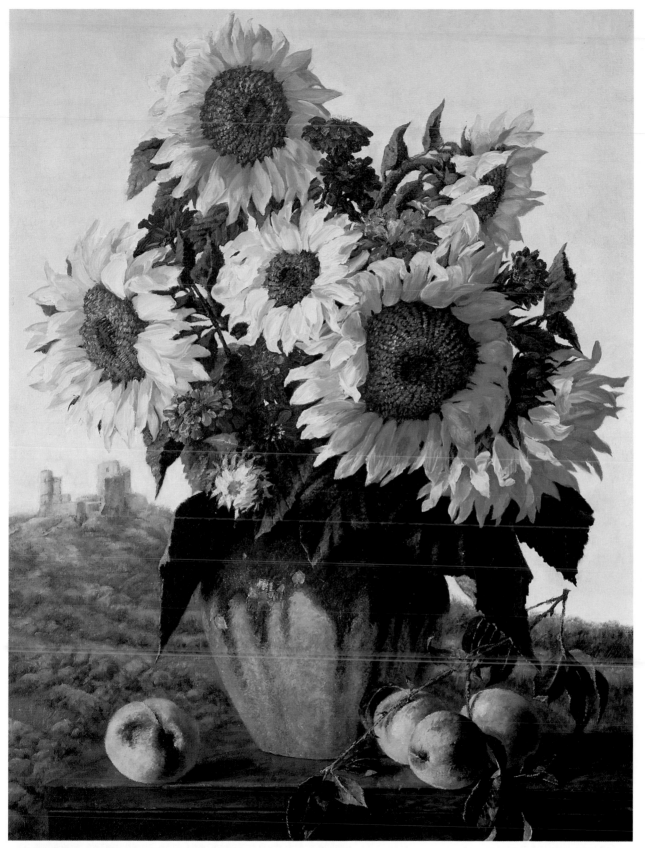

3. Establish Values

Once foreground values were established, I could determine how light or dark the background could be and still stay in the distance. I decided to make it a bit lighter and slightly reduce the Yellow Ochre in the ground plane. The pattern on the vase was painted last.

SUNFLOWERS OVER
CASTLE RUIN
27" × 20" (69cm × 51cm) Oil on
linen

TWO-POINT PERSPECTIVE

When I was a child, my dad, the builder, taught me how to draw in perspective. He taught me as he understood it from his practical knowledge, and I thought it was magic. Other children drew their house or church as a square with a pointed roof. I drew mine from the side, with the parallel lines moving toward vanishing points on the horizon. I secretly thought my drawings were the only correct ones. I was wrong. I learned later that both were correct.

The other children were drawing in *parallel perspective*, although I doubt they knew it. This simply means that the sides of an object are parallel to the picture plane. You are looking directly at it and can see only one side.

My drawings were in *oblique (two-point) perspective*. The object is placed at an angle to the picture plane. You can see two sides, and there are two vanishing points on the horizon. A vanishing point is that point on the horizon where parallel lines seem to converge.

FALL HARVEST (incomplete)
18″×22″ (46cm×56cm) Oil on linen
This unfinished painting still shows construction lines used to draw the basket in perspective and the diagonal construction lines used to locate the center of the basket in order to center the handle.

This perspective drawing is of a simplified basket similar to the one in *Fall Harvest*. From point A, the front corner of the basket, lines recede to the two vanishing points (VP1 and VP2) on the horizon line. Parallel lines travel to the same vanishing point. Lines AD , CB and KL are parallel and meet at VP2; lines AJ, CK and BL are parallel and meet at VP1.

Here is a gift of geometry to help you locate the center of the basket and thus properly place the handle. To find the center of any rectangle, draw diagonal construction lines from corner to corner. In this drawing they are lines AB and CD. Where these two diagonals cross (point E) is the center of the rectangle. Project a vertical line up from point E. Decide how high you want the handle of the basket and project a line from that point (F) to the vanishing point, VP1.

The handle must also hit the center of the basket on the far side. To find this point, project a line to vanishing point VP-1 from

the place where line EF intersects the top of the basket; here it is labeled point H. The line projected from point H to VP1 will intersect the basket on the far side at its center (point I). Project a vertical line up from there to find the far side of the top of the handle, point G.

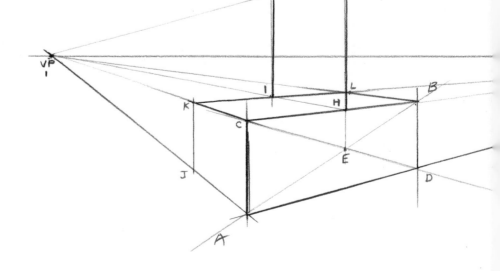

FALL HARVEST
18″×22″ (46cm×56cm) Oil on linen

HORIZON LINE

VP
2

PEARS ARE CONES

The cone shape is often repeated in nature. The pear is a good example. It is simply a cone with a waistline. Thinking of it in these simple terms helps you turn it in any direction you wish and still get the modeling right. You can stand it straight up, lay it on its side or even have it point directly forward.

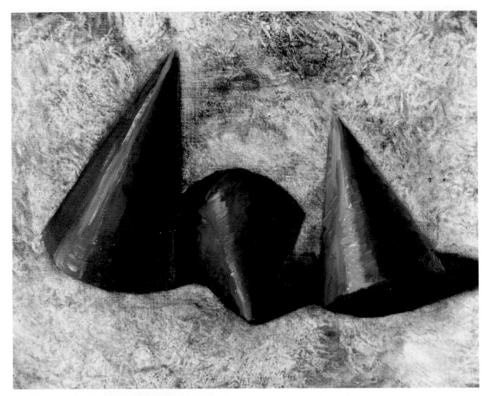

1. Basic Cones Modeled

Cones are the basic shape of many forms in nature. Learning to model them can help you model more complex forms.

2. Simple Shapes Modified

The three cones, with simple modifications in shape, become pears.

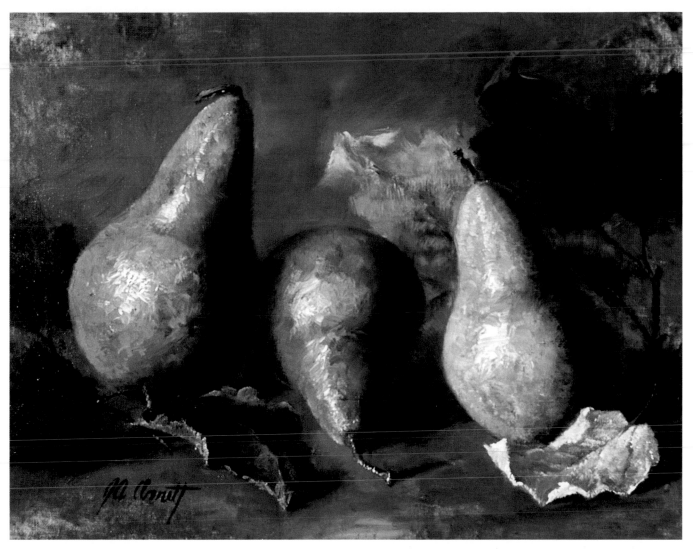

3. Finished Pears

With all their details and color variations, finished pears still maintain the basic cone shape.

PEARS AND AUTUMN LEAVES
8″×10″ (20cm×26cm) Oil on linen

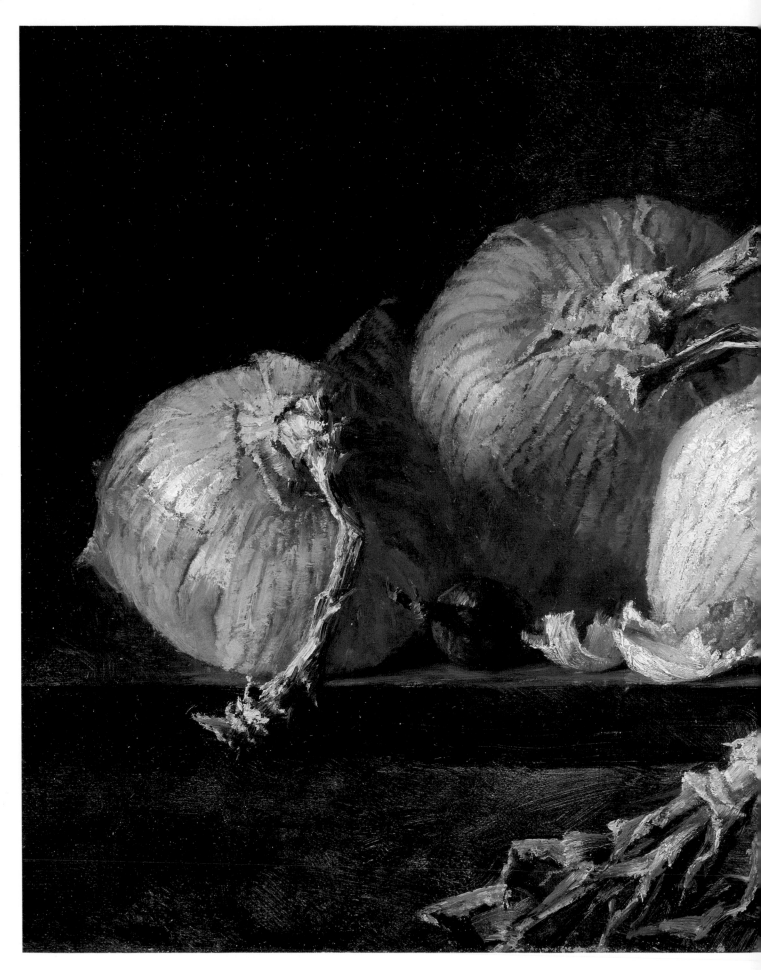

GRAND ONIONS
12″×16″ (31cm×41cm) Oil on linen
Each of these onions is a variation of a
sphere. No detail or small form dominates
the larger shape.

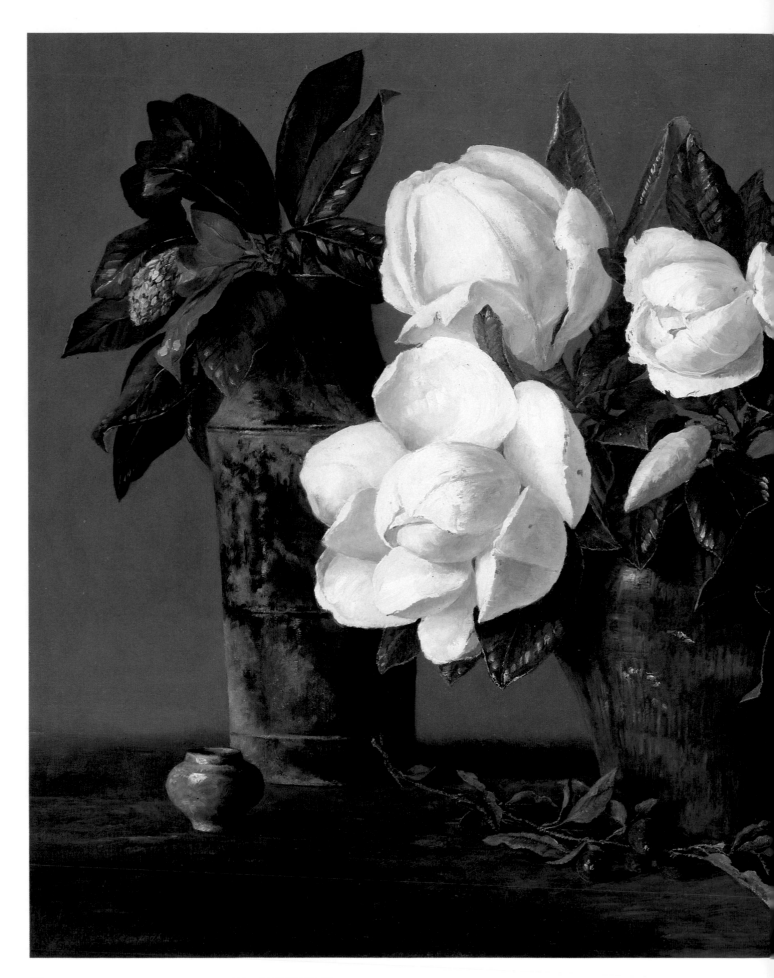

MANY VASES ARE CYLINDERS

You can model almost any vase if you understand the cylinder. Use the cylinder as a construction aid. Try this the next time you include an interesting vase in a painting. Draw a cylinder, then measure and draw a construction line down the center of the cylinder. Draw horizontal construction lines at the levels of the vase where it deviates in shape from the basic cylinder. By marking points of equal distance from the center, and following the points on each side, your vase will always be symmetrical.

This drawing illustrates cylinders with construction lines drawn down the centers. The horizontal lines were drawn across the forms to help locate points where the vases deviate in shape from cylinders. Symmetry is important, and the use of these construction devices can help you succeed.

MAGNOLIAS WITH CRAB APPLES
26″×30″ (66cm×76cm) Oil on linen
Both of the vases in this painting were drawn using cylinders as construction devices.

Communicating With Texture, Light and Detail

To communicate the nature of your subject, spend time getting to know it. Understanding is possibly the most important of your tools. Train yourself to look for characteristics. This will help you learn to paint them. Touch. Think. Observe how light hits the subject. Now you can decide how to translate your knowledge to canvas.

SOUTHERN MEMORIES, 20″×24″ (51cm×61cm) Oil on linen
The surface of magnolia petals is soft and velvety. Painting the lights softly helps describe this surface. The highlight also seems dispersed. This is one case where I switch to soft-fiber filberts. The green leaf tops are glossy. Crisp details and hard edges can help communicate this surface. The highlights also transmit this information. Edges, highlights and contrasts in the back of the picture plane are more subtle than those in the foreground. Undersides of the magnolia leaves are softly painted too. The brass bucket, glazed pottery and Chinese cricket box are hard surfaces with reflective qualities. They have crisp, impasto highlights.

Getting to Know Your Subjects

Texture is what the surface of something feels like, as well as what it looks like. That's why I like to pick up my subject, turn it around in my hand and get to know its characteristics. It's taken me some time to really understand some of my subjects. I grew antique roses for four years before I became comfortable with them and felt I could do them justice. I grow grapes and cabbages because I want to paint their *real* textures—before the grocer has washed and polished them.

Opaque surfaces don't allow light through them; they reflect or disperse light. But their surface textures change the reflection or dispersion. Is your subject soft and fuzzy, like a peach? Are flower petals velvety? Does your pot have a soft, worn glaze, or is it shiny? Does the surface disperse rather than reflect light? Is it glossy, like a pepper or an eggplant? Is it reflective, like glass or metal? Wet surfaces, like just-sliced cantaloupe or watermelon, are highly reflective. Is a surface damaged or tarnished?

PAINTING A VARIETY OF TEXTURES

One thing that makes a painting interesting is variety, especially in the textures. *Rose Melody* was commissioned by a wonderful opera singer as a gift to herself to mark a milestone in her life. I wanted the painting to reflect her sparkle and depth. She asked for the roses; the sheet music was my idea, and she happily sent some of her own. W.M. Harnett (American, 1848–1892) used music in some of his wonderful trompe l'oeil paintings, and I wanted to try it. The rest of the subjects were things I did to surprise this talented lady. The painting has a wide variety of textures, each with an individual treatment.

RENAISSANCE PEACHES, 25″×21″ (64cm×54cm) Oil on linen
Peaches are a wonderful example of distinguishing the nature of a surface by the way you handle the brush. Peaches have a fuzzy texture. I used the brush to create soft edges and painted dispersed highlights. If I had painted hard, crisp edges with crisp highlights, the peaches would have become nectarines.

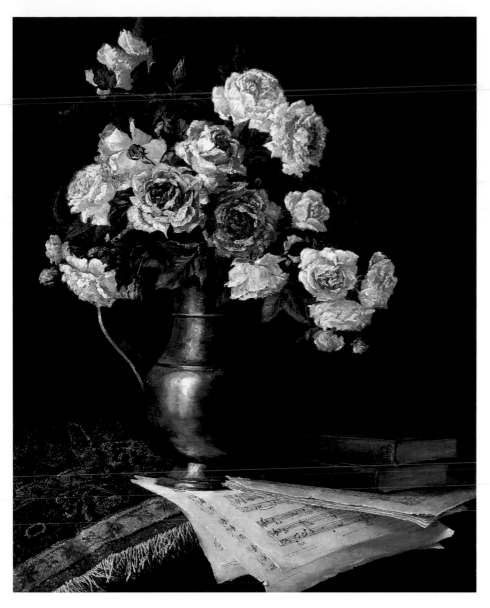

20″×16″ (41cm×51cm) Oil on linen

Variety adds interest to any painting, not only in the subject matter and scale of objects, but also in the variety of textures represented. In *Rose Melody* there are five distinct textures, each with its own treatment.

The flowers were painted with the most impasto and the most vigorous brushstrokes. They wanted it that way. Pewter is a quieter metal than some others and seems a good choice in this painting. Brass, copper or silver would have demanded more attention. This is an old German stein and, as the painting was done for an opera singer, the character of the piece also seems right. While pewter is not as highly reflective as other metals, it still has reflective qualities. The subtle reflections of the books and sheet music on its underplane add interest to the lower part of the painting.

The books are placed in a position to direct the eye back into the painting. The old leather has little texture and was painted softly. Another reason the books were included is that it gave me an opportunity to write a special date and name, masquerading as book titles.

The Persian rug on the left has an interesting texture. It is fuzzy because the threads of the weave are knotted at the back and clipped on the front. They stick up. I kept the brush strokes perpendicular to the direction of the rug to further suggest its construction. The angle of the rug was designed to lead the eye into the composition.

To use the space in front of the picture plane, I decided to employ a device often used by W.M. Harnett. The music, advancing forward off the table, occupies that forward space. Flat sheets of paper have little texture to work with, but there are several techniques available to help bring them forward. Sharp edges come forward, so I used them. The edges of the music are very sharp. Detail comes forward, and the music was more than willing to cooperate. Impasto comes forward, so I stacked bright highlights on the edges of the music.

This is for Tomorrow

Keep your hands in your pockets when you go to European produce markets: It's your only guarantee of not offending someone. The vendors, justifiably proud of their products, don't like for you to handle anything. They want to do it—and to help you make your selection. I'm safe only with my hands in my pockets because I inevitably reach for something to study as a possible prop. I'm seldom selecting things to eat, so my interests are not in freshness and taste. I'm interested in color, shape and texture. I once selected a beautifully veined melon to paint. The farmer disapproved of my choice and showed me another that was ready to eat immediately. I explained that my purpose was not to eat it, which insulted him. I've since learned to say "This is for tomorrow" in several languages.

Handling Paint

There are wonderful artists who handle all textures in the same manner. Their canvases have a strong overall paint application and they prefer not to concern themselves with the texture of individual subjects within a painting. This can be very beautiful.

Other artists use very little paint on the canvas, creating their texture with detail and finely observed drawing. This can also be beautiful.

These are the extremes. I prefer a different approach and enjoy handling each subject according to the nature of the object and its position in the picture plane.

One great advantage of oil painting involves the handling of textures. We can paint texture with as much or as little paint as we choose. We can use the natural characteristics of our oil paint to create effects which are far more difficult to achieve in any other medium. Thick, rich paint achieves many luscious surfaces; thin paint is also a versatile tool. The combination of the two, plus the infinite variations between, allows us to create an enormous range of textural illusions.

It's difficult to make broad statements about texture. However, I believe that if you study your subject enough to understand how it was made, how it grew, how the light strikes it and how the subject handles the light, the subject will communicate with you. The luscious meat of a watermelon does not want the same treatment as an aged piece of sheet music. A sunflower demands great energy and powerful impasto; a rose prefers gentler treatment. Listen. Observe.

The heavy weave of a tapestry is a good place to observe the importance of understanding how something is made and how this knowledge can help you paint it.

1. Major Compositional Elements

Webster's New World Dictionary gives the second definition of texture as "the character of a woven fabric, resulting from the arrangement, size, quality, etc. of the fabric's threads." Think of this when painting the texture of a fabric such as the one in this painting.

Establish large shapes, judging object placement and spatial relationships. Suggest major shadow shapes. At this point, the composition of the major elements is my main concern.

2. Fabric and Shadows

When painting a complex pattern, study it and determine if there is one color that dominates. In this case, the color holding the others together is a dull ochre. I paint the entire fabric this color. I have kept the feeling of the strong weave by choosing only horizontal and vertical brushstrokes. By taking advantage of the similar weave of my linen canvas, I allow some weave of the canvas to show through. State the important shadows with greater strength.

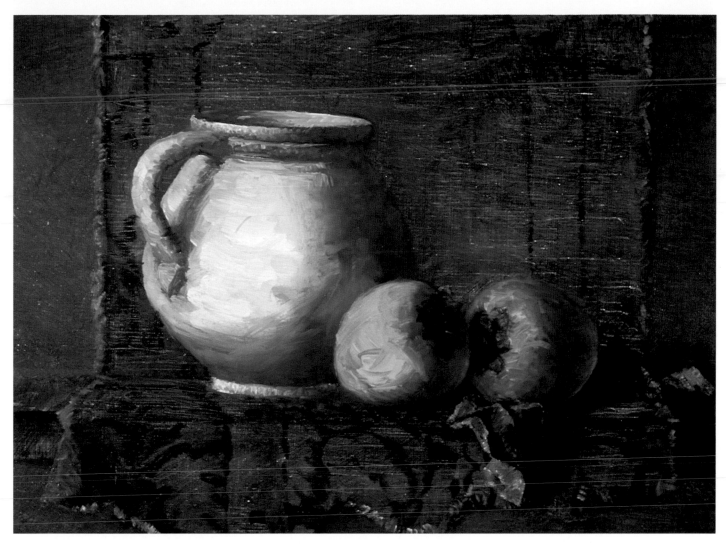

3. Objects and Tapestry

I have solidified the pot and the persimmons by painting their light sides and once again strengthening their shadows. The tapestry is important in this painting, but not as important as the other objects. I chose to include it in the painting for good reasons. It is an interesting texture to contrast with the other textures, it is a unifying element and it helps to create depth in an otherwise shallow picture plane. I begin the tapestry pattern using Ultramarine Blue to define the dark negative shapes between the woven flowers and leaves.

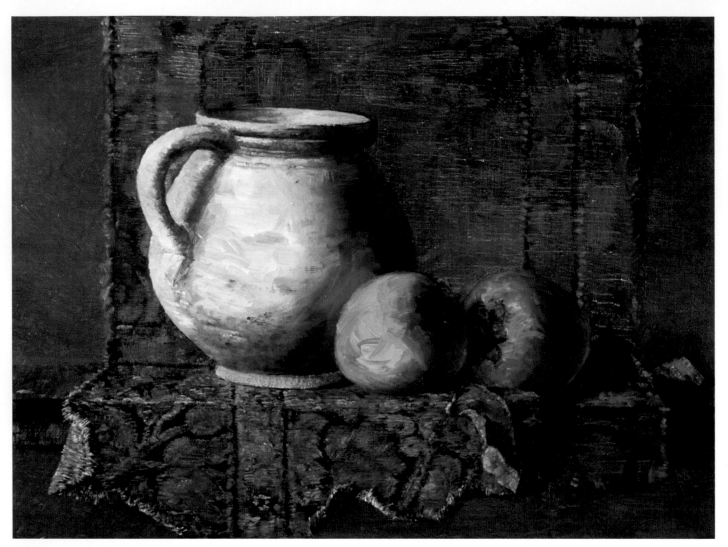

4. Pattern and Pot Details

Develop the pattern, adding other colors, details of flowers and stylized leaves. Paint strokes
here are still either horizontal or vertical. The pattern on the fabric in the foreground is
developed with thicker paint, greater contrasts and more definition in the drawing than
the same pattern in the background. This helps the foreground fabric come forward. The
thinner paint, lower contrasts and closer values of the fabric in the background help it
recede. Details are added to the antique Italian pot, helping to suggest its age and wear.

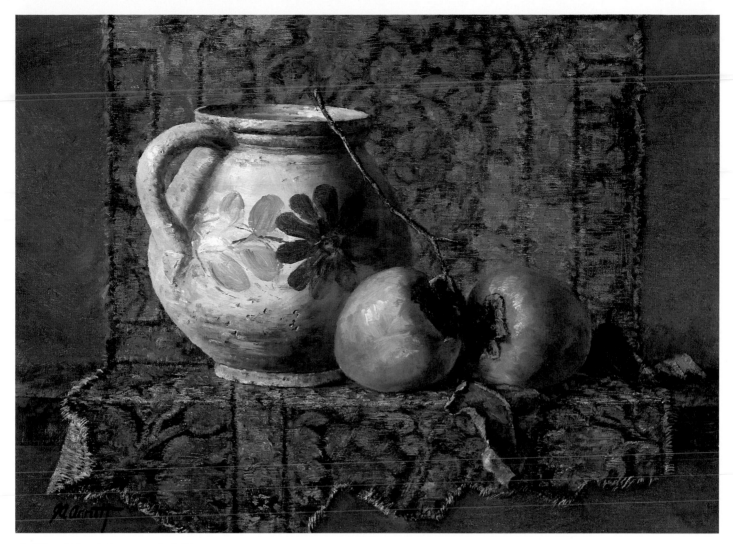

5. Final Decisions and Adjustments

Once the fabric pattern is complete, I make some final decisions and adjustments. I have to decide if the foreground fabric is strong enough and the background fabric weak enough to keep them in their respective places in the picture plane. I strengthen the edges of the uneven foreground textile, allowing the light to strike the threads and turns of the fabric with greater force. I check again to make sure that the direction of the brushstrokes helps communicate the heavy weave of the textile. I choose to allow threads of the linen canvas to remain exposed in the background. Next, the bright orange persimmons are finished. I want the persimmons to seem even brighter, so I take the creative license to change a part of the pattern behind them. I *invent* a lighter flower in the design behind the persimmon on the right and allowed the orange of the persimmon to bleed up into the atmosphere. This is not a reflection. It is a simple fabrication to lighten the area behind the persimmon, thus making the persimmon brighter, glowing in the composition. The persimmon on the left has the natural advantage of reflecting into the pot. Remaining details are added in the final stage: the branch of the persimmons, the pattern on the pot and more of the chips and scratches to further communicate the age of the pot.

PERSIMMONS WITH TAPESTRY AND ITALIAN POT
12″ × 16″ (31cm × 41cm) Oil on linen

LETTING YOUR PAINT "PERFORM" TEXTURES

Some textures are best achieved by letting the paint "perform" them. My favorite example is watermelon. This subject lends itself to heavy impasto. Watermelons have a white vein running through red meat, so use red and white. Really load your brush *without* mixing the two colors. Place the brush on the canvas where light hits the watermelon, and let the pigments stay where they fall.

You can't be afraid of thick paint. You must not go back and work the paint. You will lose the fresh, wet feeling this technique achieves. Of course, there are highlights you must deal with, and this does mean going back in to place them. Put them down with thick, cool white and leave them.

Subjects where this technique is a natural choice are the meat of cantaloupes and pumpkins, as well as heavily textured surfaces like oranges. It also works well for flowers that are not a solid color.

Flowers can be wonderful teachers if you let them. One valuable lesson I've learned from them is to put paint down with assurance and leave it. Lilacs taught me this, but it works in many applications.

I find myself using this when painting with thick paint. It also works with thinner applications, and especially with the palette knife. This is useful when painting the light and highlight on a thin form such as a stem or branch. Mix the color you want and use the edge of the palette knife to put it on the form. Don't stroke, just place it.

Don't Overmix Pigments

It's almost always a good idea *not* to overmix your pigments. The visible presence of the parent colors in a mixture is exciting, allowing the eye of the viewer to do some of the mixing.

WATERMELON AND BRASS
14″×18″ (36cm×46cm) Oil on linen
The meat of a watermelon is luscious. This texture is only visible on the planes where the light strikes it. Shadow planes should be kept simple. This is one reason I cut and break watermelons, not simply cut them. You get a variety of planes and many more interesting surfaces catching the light than you would with a simple, straight slice. Always buy several watermelons; you never know if the breaking is going to go well. Application on the planes facing the light is extremely thick, done with paint that had *not* been mixed. The red of the meat and the white of the veins through it were put down simultaneously with a brush loaded with both colors. Any mixing of the pigments happened by chance on the canvas. Highlights of bright, cool white were stacked on top of the still-wet pigments. These too were done with extreme impasto.

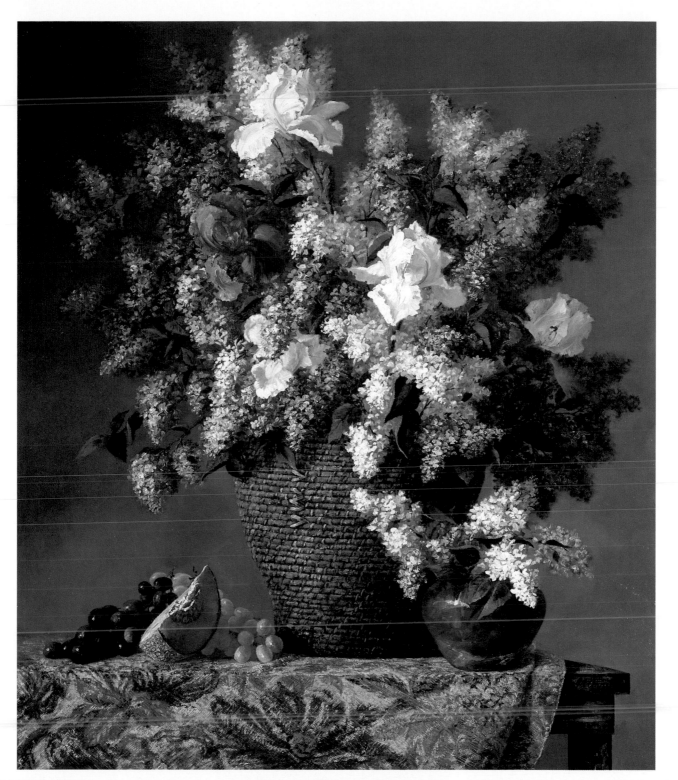

SULLIVAN LILACS
30″ × 24″ (76cm × 61cm) Oil on linen

Lilacs are composed of hundreds of individual blossoms. To get the *feeling* of a lilac, it is best to put the paint down to suggest the individual petals and to resist any blending. While they collectively do form cones, they are also individual petals and must retain that characteristic. The trick is to put the paint down at the correct value to form the cone. The value follows from light to highlight to shadow to reflected light, and sometimes on to cast shadow. Halftone is really not a consideration here. It tends to take care of itself when you paint wet-into-wet. Place the simplified shadow down first, and then stack the lights on top, being careful to retain the integrity of the shadow side. A little reflected light on the shadow side helps the cone to turn away. Use more paint on the foreground lilacs than on those in the background; it helps achieve greater depth in the picture plane. The lilacs on the shadow side of the composition are receiving very little light and are painted almost as silhouettes, modeled with only a touch of reflected light. Not only should each lilac turn from light to shadow, but the entire bouquet should turn as well.

Handling Your Brush

Another important element for achieving exciting textures is learning how to use your brush with authority. The pressure you apply to the brush, even without changing color or value, can achieve a vast variety of textures. You must, however, always remember that you're using a brush, and that you must use it as a brush; you must not treat it like a pencil. A pencil is a wonderful instrument and a valuable tool, but the power of the brush in painting must not be wasted.

HOLDING YOUR BRUSH AT THE END

My father could drive a 10-penny nail through a 2×4 with a few powerful strokes. He knew how to use his tools. He once had a man on his crew who would not hold his hammer properly. My dad went up to him day after day to tell him, "Hold the hammer at the end." This went on for quite some time, until the day my dad lost patience. He walked up to the man and said politely, "Let me see your hammer for a minute." The man handed him his hammer. Dad walked over to the table saw and sliced six inches off the handle. He walked back to the man, handed him his hammer and said, "Now, hold your hammer at the end."

This story became legend in our hometown, contributing to years of good humor at the coffee shop where all the builders met in the early morning. I'll never forget the story, nor the principle it taught me.

I think about the story as I remind myself that the end of the brush is where the power is. Holding the brush at the end forces you to make painting motions. Holding it close to the ferrule (the metal part that holds the hairs or bristles) causes you to make drawing motions. These strokes are sometimes necessary, but they should not become the majority of the strokes you make.

You don't want to waste the power, the excitement or the enjoyment of making brilliant, authoritative brushstrokes. Some paint applications are possible *only* with singular, assured strokes.

Holding your brush at the end can help you stay loose. Many subjects are far more difficult to paint in a convincing manner if you allow yourself to get too tight.

SELECTING THE RIGHT SIZE BRUSH

Study your subject and ask, "How large a brush will this subject tolerate?" A larger brush accomplishes several things for you. The bigger the brush, the more paint it holds. This encourages you to really *use* the paint and helps break down barriers you may have about using impasto. Larger brushes encourage simplicity. Painting irises taught me this. I try to finish the main body of each iris petal with one stroke. This dynamic, dramatic motion is exciting and convincing. A small brush would make this motion impossible. It's hard to get picky with a no. 12 brush.

FINDING YOUR STYLE

These are a few of the brush-handling techniques I enjoy; you'll discover others on your own. With time and experimentation, you'll find things that work well for you, that will become your signature, your personal handwriting. Many artists may use the same techniques and principles, but no two artists' styles need look alike if each tries to make an honest, personal statement.

This close-up of the beginning of *Iris Fiesta* shows how casually I block in the flowers. I do not make a careful drawing. I want the spontaneity of simple, powerful strokes. I do not overmix the parent colors, and I try to simplify the number of brushstrokes required to communicate the form. These bearded irises were painted life size. The petals are wide enough to accommodate a big brush, which encourages you to accomplish your purpose with greater simplicity and helps you get the feel of the sweep of the petal.

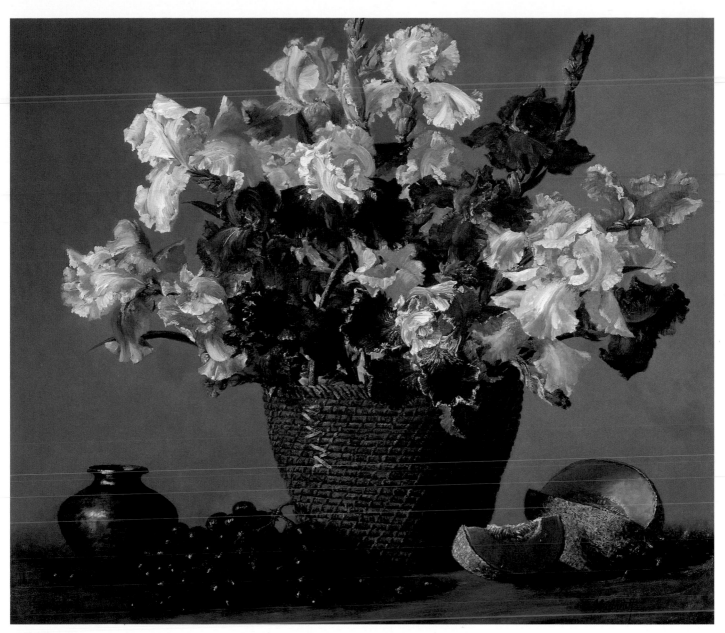

IRIS FIESTA
26″ × 30″ (66cm × 76cm) Oil on linen
All of the irises in this painting were done with either no. 10 or no.
12 brushes. They have vitality and life. Sometimes, naming a paint-
ing can be the most difficult chore. In this case, it was easy. In *Iris
Fiesta*, it really looks like there's a party going on.

Glowing Metals and Reflections

I sat in my studio one day, painting a brass bowl, proud because my brush-work was exciting; the colors were varied and luscious.

Picking up my brushes the next morning, I was met with some surprises. The colors were different. There were forms I did not understand and the shape of my bowl was distorted. That's when I learned that metal loves to trick you, play with you and force you to think.

On day one of my humiliating bowl experience, I had worn dark blue jeans and a white shirt. My studio easel is a light maple color and had been positioned close to the bowl. Without thinking, I had painted the reflections of my jeans, shirt and the long vertical edge of the easel.

On day two, I wore khakis and a light blue shirt. My easel was turned to a slightly different position, one where its edge caught no light. The dark blue of my jeans, the white of my shirt and the bright edge of the easel were no longer visible in the bowl, and my painted form made no sense at all. Unexplained elements were confusing, and I realized that I had been tricked.

Like everything else in painting, *understanding* is your first and most important tool. With metal, you must not only understand what you're seeing, you must also understand what the metal is seeing. Without a thorough understanding of the metal's point of view, the form will never be convincing.

It's helpful to eliminate some preconceptions many of us have. We assume we know the color of a metal, so we don't study and look for all the other colors that may be there. This idea could cause us to miss much of the excitement. Assume you *don't* know the color. Copper can have an orange, pink or silver hue, or sometimes a green feeling. There can be base metal showing

through or tarnish on top. Brass can have warm ochre, green, black or pink undertones. The color you see depends on age, variations in composition, wear, the environment surrounding the form and the light that is striking it.

We almost always assume that the value of a metal surface is lighter than it is. This may be because metal has highly reflective qualities. It vigorously bounces light, and we assume we can make it look bright if we paint it light.

In fact, metal never looks shiny and bright if you don't start dark enough. Look for the deep, rich darks. Without darks, reflections and highlights have nowhere to live, no place from which to glow.

Breaking the Rules

Know the rules, but understand *when*, *how* and especially *why* you may choose to break them.

TURNIPS AND COPPER 12″×16″ (31cm×41cm) Oil on linen
The bucket in this painting is of Turkish copper. In processing, it is dipped in a bath of tin. This veneer is thin. Most of it has worn off. I used a mix of black and white to suggest the surviving tin. The shadow of the bucket was painted with a mix of black and Rose Madder Deep. This dark was used for the underplane of the bucket as well. The body of the bucket facing the light was painted with Cadmium Orange, Burnt Sienna and Rose Madder. These colors were not thoroughly mixed and all of them show in the finished painting. I painted a bright white highlight on the lower part of the bucket and allowed it to change to a bright orange as the shape straightened higher up the bucket. The highlight on the lower part of the surface was caused by the sky. The orange on the upper surface was caused by a reflection of an adobe wall outside. This is breaking the rule of eliminating influences of elements from outside the picture plane. But it helped the bucket read as bright, shiny copper.

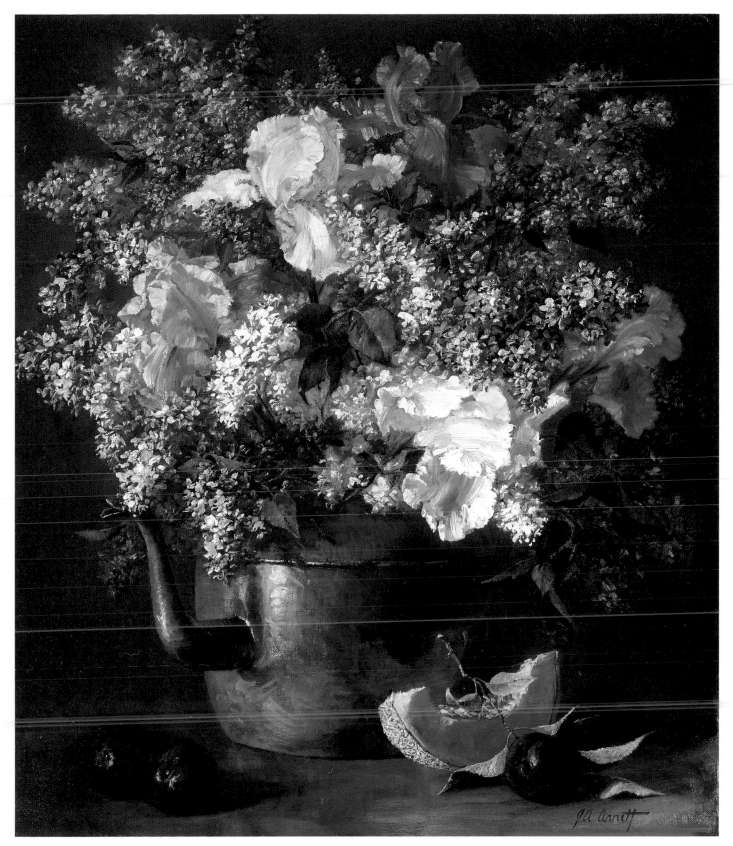

KETTLE OF LILACS AND IRISES
21½″ × 18½″ (55cm × 47cm) Oil on linen
This kettle is a heavier, denser metal than Turkish copper. It is solid and has no other metal showing through. The choice of a quieter, darker copper for this painting was purposeful. The kettle has several functions, but lilacs and irises are the subject. The shadow is a mixture of Rose Madder Deep, black and Cadmium Orange. Pigments to mix the light are Burnt Sienna and Cadmium Orange, with a little black to dull the surface a bit. The highlight began as Cadmium Orange and white and ended with a flourish of pure white stacked on top of the still wet orange-and-white mixture.

This is a photograph of the samovar in *Russian Mammoth Sunflowers*. I had finished painting the other elements and the sunflowers had shifted positions and wilted, but I shot this photo to illustrate how confusing reflections from outside the picture plane can be. The stripes down the middle of the samovar are reflections of the side of my easel and the edge of the canvas. These reflections do not explain, they only confuse. I left them out of the painting and included only those reflections that represent objects within the picture plane.

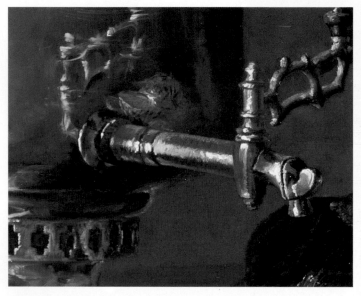

The reflection in the samovar shows the back of the spout's handle. Our view of this handle is from its shadow side. The samovar sees it from the side facing the light. That is why the reflection records the exciting highlights of the handle. The other reflections in this detail are of a higher side view of the white and blue porcelain cup, saucer and teapot, and of the yellow onion closest to the cup. The presence of the samovar's spout hides the reflections of the other onions from our view. The location of the cup and saucer blocks the reflection of the turnip and shallots from the view of the samovar. The bright glow off the top of the cup is the reflection of the light hitting the gold design.

RUSSIAN MAMMOTH SUNFLOWERS
36″ × 32″ (92cm × 81cm) Oil on linen

This painting was commissioned by a gentleman who requested a Russian theme. I grew the sunflowers, which are one of the largest varieties. My client provided the samovar and the delicate porcelain. These giant sunflowers are my favorite and I always enjoy painting them. Painting the brass samovar was a challenge. It was beautiful, but it reflected everything in the setup and everything in the studio, including the artist. The challenge was to unscramble the mystery of the source of all of these reflections and include only those that contributed to the painting. I eliminated all the reflections that were not actually of something within the picture plane. In this case, what I didn't paint was more of a challenge than what I did paint.

COPPER WITH ORANGE AND DAFFODILS
24″×20″ (61cm×51cm) Oil on linen
No reflected image is as bright or distinct as the object being re-
flected. The white cloth, the flowers and the orange are not as bright
in their reflection in the copper bucket as they are on the table.

Painting Highlights

You can discuss painting all day long, and read wonderful books on it, gaining truly helpful knowledge. But you learn by doing. Nowhere is it more true than for the highlight on a metal object. This brushstroke or slash of the palette knife takes courage and practice. You learn to do it by doing it again and again. In return, it gives a sweet reward.

Highlights fall on the turn or corner of the form closest to the light source. In my studio, this source is the north window. If the turn, or change of plane, is abrupt, the placement of the highlight is simple to see. If the plane turns slowly, the placement is a bit more difficult, but it remains at the point on the form closest to the light source.

By raising the value of the area around the point where the highlight falls, you give the impression that the highlight glows into the surrounding area. Place the highlight into the area you have prepared for it with thick paint. This is no time to be timid with either the amount of paint or the energy of the application. The color of the highlight should be cool, relative to the colors surrounding it.

Brass, copper, silver, pewter and all the other metals can be wonderful teachers. They can train you to look and force you to understand what you see. They encourage you to explain. The things you learn from painting metals translate into other areas of painting. Other surfaces, such as glass or highly glazed pottery, present many of the same problems you learn to solve when painting metals. Reflections and bright, glowing highlights belong to these surfaces as well. I learn something new every time I paint a metal object. I'm reminded each time that this is one of the most enjoyable experiences in painting.

1. Major Elements and Shadows

Establishing the shape of the entire painting *first* ensures that the composition will fit the picture plane. This is important in every composition, but it is vital in a format this small.

2. A Simple Background

Laying down a simple background allows me to further determine that the big shapes are properly placed.

3. Color of Subjects Begun

With major shapes established, I begin to address the subjects' color. I shift the temperature of the shadows of the apples to a warm green, using black mixed with Cadmium Yellow Pale. I use this same warm green, with the addition of more black and a bit of Cadmium Orange, to state the shadow of the brass pot. I also lay down a base color for the light side of the brass in a neutral green.

4. Apples and Brass

I painted the local (actual) color of all the shapes. The bright green of the apples is painted and their reflections in the brass are put in at the same time. Notice that the tiny vase is reflecting the same apples twice—once directly behind the apples and again where the vase turns upward. This second reflection is smaller for two reasons: The upturned plane itself is a smaller surface and it is a bit farther away from the source of the reflection. Build up the light side of the brass, beginning the preparation for the highlights. The highlights on metal, more than anything else, contribute to creating a glowing effect. This glow is enhanced by preparing the place for the highlights. The highlights on this highly reflective surface are so bright that they seem to glow into the areas around them.

5. Studied, Observant Decisions

I simplify the background a bit to keep it from competing with the foreground. I brighten the area where the highlight on the brass will fall. I simplify and dull the reflections of the apples. In the earlier stage they were very bright; this confused the form and kept it from turning. No detail on the shadow side should be brighter than the part of the form facing the light: This only confuses the shape. Lady apples are small, bright green apples with a red design. It is important when painting a subject like this to determine if it is a green form with a red design or a red form with a green design. It makes a big difference in the order you decide to paint the colors. Making a clear decision and sticking with it helps you avoid contaminating the colors and painting mud instead of a bright, beautiful design. I painted this design wet-into-wet, using a lot of paint and a very light touch to prevent picking up the green below. The wet paint allowed me to delicately drag edges together and create believable shapes. Don't overdo this idea, or you will lose the integrity of the red design.

Remember that the brass does not "see" the same side of the apples as you do. The brass is looking at the back, the opposite side, and there is a different design there. Therefore, when you paint the reflections, you must observe carefully, and perhaps even walk around and study the forms from the other side.

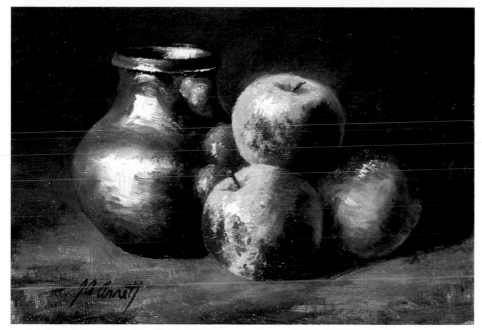

BRASS WITH LADY APPLES
5″ × 7″ (13cm × 18cm) Oil on linen mounted on Masonite

6. The Final Highlights

The apples are hard surfaces that are a bit shiny. Their highlights, painted with white mixed with a touch of Cobalt Blue, are applied with impasto and are not blended.

The highlights on the brass are also white mixed with a tiny bit of Cobalt Blue. These are applied with very thick paint and allowed to bleed into the surrounding areas. This helps to create the illusion of a glow to the metal.

Handling Translucent Objects

Light can be reflected, refracted or transmitted. There are times when I think light may even have a sense of humor, because it does such delightful things. Once you think you've learned to handle light in every situation, it does something else; you have yet another effect to observe and learn about. Light, the real key to painting transparent and translucent objects, is a wonderful teacher.

IN, AROUND AND BEYOND

Transparent and translucent objects allow us to see other objects as we look through them. The appearance of the things we see through these forms also undergoes changes due to the transmission of light. Objects seen inside or beyond a translucent form appear less distinct. Edges are softer, colors are dulled and values are brought closer together. Observation is the best tool you have for representing translucent and transparent objects on a flat picture plane.

TRANSLUCENT OBJECTS

Translucent objects are kinder to the painter than transparent ones, but we are still looking for changes in light intensity and color temperature that occur in objects in, around and beyond them. Translucent objects allow some light to pass through them, but not the complete spectrum of light waves. Some are stopped completely as light strikes the object; others pass on through. As light passes through and exits on the shadow side, the temperature of its color becomes warmer. This is particularly obvious with translucent objects containing water, such as thin slices of melon, thin slices of lemon, grapes, fresh kernels of corn and pomegranate seeds.

Kernels of fresh corn contain water. This adds to their translucent character. Light, where the turning of the larger form allows, passes through the translucent kernels and exits on the shadow side. One key to creating the illusion that you are painting fresh corn and not dried corn is to suggest this transmitted light. This unfinished detail has lights and shadows of the kernels blocked in. They have yet to receive highlights and have no transmitted light traveling through them.

Bright highlights have been added to the kernels of corn with pure white impasto strokes. The transmitted light was painted with Cadmium Yellow Pale at the point where the light exits each kernel, as the turning of the larger cylinder of the ear of corn allows. This suggests that the kernels still contain water and are, therefore, still fresh.

1. Establish Large Shapes

This step determines if elements fit comfortably into the picture plane. The general shape of this composition is a triangle. All of the elements fit inside this shape with only slight variations.

2. Place Shadow Shapes

By placing all shadow shapes at once, I can immediately see the composition's strengths or weaknesses. These shapes are the skeleton of the painting. If they are strong, the painting will be strong. If this skeleton is not strong, now is the time for changes.

3. Begin the Lemons

I paint the lemon slice and the interior of the sliced lemon next for two reasons. The lemon slice, or more specifically the transmitted light passing through it, is the subject of the painting and the strongest element. Its strength determines the strength of the other elements in the painting. Also, once the lemon is cut, it quickly begins to dry. I want to paint it while it is fresh and still wet. I keep a spray bottle of water on my tabouret and often spritz the lemon to keep it moist. Light hitting the side of the lemon slice facing the light source is cool. I loosely mix Cadmium Yellow Pale with white and apply it with thick strokes in the direction of the pulp fibers. Some of the light passes *through* the translucent slice of lemon. As light exits the slice, it appears extremely warm. I use pure Cadmium Yellow Pale for this exiting light.

4. Begin Other Elements

With the lemon slice almost complete and its strength determined, I begin to paint other elements. The grapes are blocked in as simple forms and the skin of the lemon is painted with Cadmium Yellow Light and Cadmium Yellow Pale, using thick, unblended strokes to suggest its rough surface.

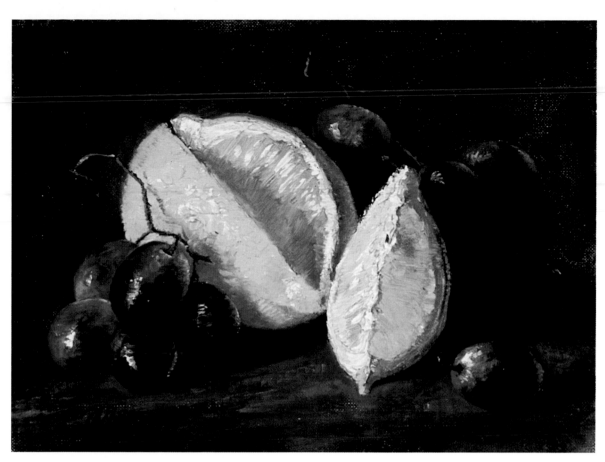

5. Complete the Fruit

I add the shadow of a seed inside the pulp of the lemon slice. This addition continues to suggest translucency.

Grapes are also translucent. They contain water and allow some light to pass through them. This particular variety of grape is both dark red and green. I chose this variety because the variations in color added interest to the small painting. Most of their shadows were painted with Rose Madder mixed with black. The color mixture of the grapes in the light depends on the local color of the specific grape. Where it is red, I use Rose Madder. Where the grapes are green in the light, I mix Cadmium Yellow Pale with Manganese Blue and dull this mixture with a little gray made by mixing black with white. This same silvery black-and-white mixture is floated over the light side of some of the grapes. Fresh, unwashed grapes sometimes have this silvery surface. The highlights are pure white allowed to trail off into the gray. On the shadow side, some light exits because the grapes are translucent. At this point, the light is warm. I use Cadmium Yellow Pale to suggest this transmitted light.

LEMON WITH
GRAPES
5″×6½″ (13cm×17cm)
Oil on linen mounted on
Masonite

Following Through With Details

Final details should follow through with the bigger ideas, but should never become the subject or call undue attention to themselves. Because details are entertaining and fun to paint, they can tempt you to lose sight of more important issues. Every stroke of a painting, including the finishing strokes, follows the same guidelines. The form must have the correct values, color temperatures and shape. It must follow the rules of aerial and linear perspective as well, in order to occupy its assigned place in the picture plane. The rules remain the same for the very small forms within a painting as well as the larger ones.

PAINTING PATTERNS ON FORMS

It isn't enough to simply draw the pattern accurately. That seems to be everyone's first instinct. While the drawing must be correct, simply placing it onto the form without thinking can quickly destroy the three-dimensional illusion of the form. The pattern must follow the form in every way.

FOLLOWING THE VALUES

First think about the *values* of the host form. The cylinder, sphere or cone moves from light to highlight, back to light, and then to halftone, shadow and reflected light. The pattern must also follow these values. Where the form faces the light, the pattern must become part of the light; where the form turns into shadow, the pattern must become part of the shadow. This sounds simple enough, but problems arise when you get lost painting the details of the pattern and forget where these details fall. The result is often a flattened form.

DRAWING THE DESIGN

Properly drawing a design on any form is important. In fact, drawing can clarify or emphasize the shape of the host. A horizontal stripe on a vase follows the ellipses of the vase and emphasizes the round form. A vertical stripe is equally suggestive of the shape.

We find stripes on forms from nature as well. These, too, can help clarify a form. Parrot tulips, for example, are cylinders gone mad. There are many varieties, and some have dramatic stripes down the center of the petals. The stripes help explain the directions of the errant petals. These stripes, however beautiful, must not confuse the shape of their host. They must follow the form and continue to help explain.

FOLLOWING COLOR TEMPERATURE

You must also follow through with the color temperatures. Where the host form faces the light, the temperature of the color is cool (relative to the warmer temperature of the shadow). The pattern on the form must also move from cool in the light to warm in the shadow. A pink flower in a pattern must become a warmer pink in the shadow of the form. If the pattern in the light is blue, it must become a warmer blue as it turns with the shadow of the form.

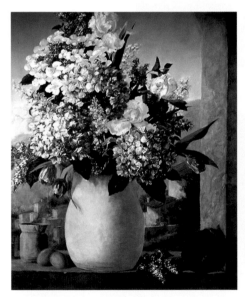

1. Lights and Shadows

The shape of this beautiful old vase from southern France is a slight variation of a cylinder. It is established first and almost completely modeled before any consideration of the chips on the surface or the flower design. I hold back on the highlight of the vase because this is more believable painted on *top* of the design. The lights and shadows are clearly established and must remain at these values through the end of the painting.

2. Chips on Vase

Chips on the ceramic surface are painted before the design. I could as easily paint the flowers first, but this way seems a bit clearer to me. It is really your choice. The chips, while adding details to the surface, still follow the values of the turning form of the vase.

3. Design and Highlight

The flower design is painted next. Even though it has significant detail and several colors, the design still closely follows the values of the host form. It is very tempting to paint the design too dark on the shadow side. To avoid this temptation, try this.

Squint your eyes *really tight*. The design should almost disappear and the value of the shadow should dominate. The highlight is painted with thick white paint and broken strokes to further suggest the texture of the aged surface.

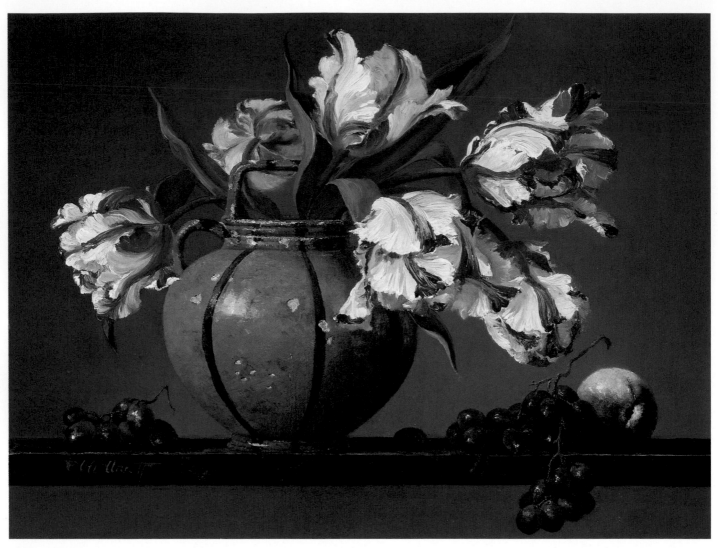

YELLOW PARROT TULIPS
13" × 17½" (33cm × 45cm) Oil on linen
The design on this simple little pitcher follows the values and the temperatures of the form. The drawing of the dramatic vertical stripes down and under the belly of the pitcher continues to explain the form.

The parrot tulip stripes are another example of how dramatic designs can help explain forms. These tulips are playful forms. The red stripes clarify and emphasize the direction of each petal.

You're in Charge

A detail that doesn't explain confuses. You're the artist. You're in charge. You can change a detail if it's not helping you with your larger goal. It's your painting, after all, and the flower will only be around a few hours. Your painting, your interpretation of the flower and your statement about it will be there forever.

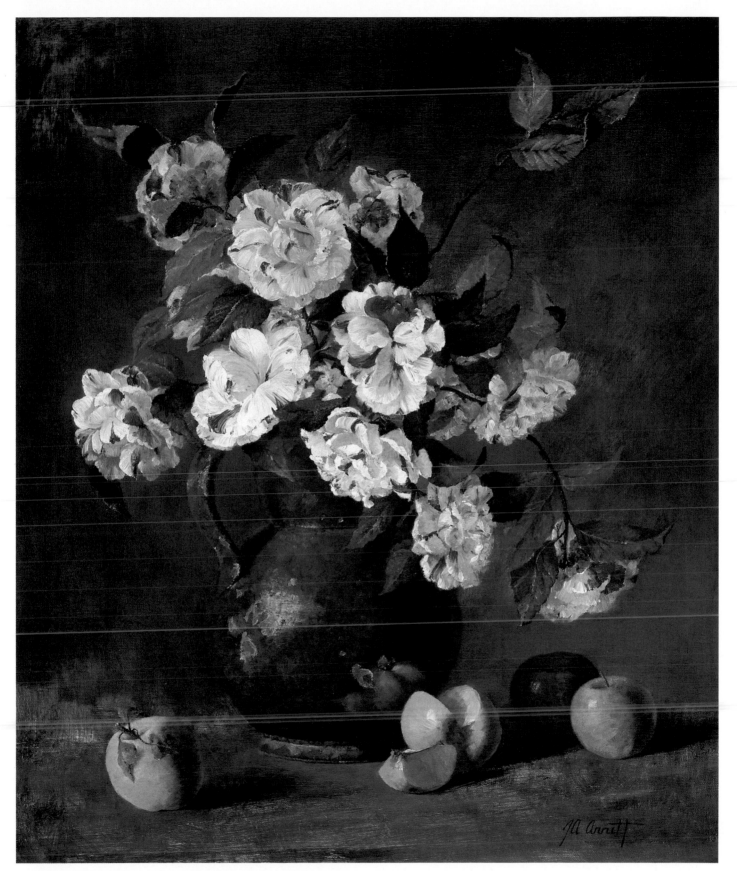

CHRISTMAS CAMELLIAS, 23″×19″ (59cm×49cm) Oil on linen
The stripes on these creamy white camellias seem very casual at
first glance. However, each stripe carefully follows the direction of
its host petal.

MODELING IN THE MOVEMENT

I was privileged to study with a legendary anatomy and life-drawing teacher, Robert Beverly Hale. I could only repeat his class for two semesters. I would repeat it today if it were possible. While his subject specifically was muscle, bone and movement, he really taught about art and life in general. Many of the principles I use today came from his life-drawing class.

One principle he eloquently explained was called *modeling in the movement*. While he taught the infinite details of the human body, he didn't want us to lose sight of the fact that these were elements of larger forms. The small forms should be modeled with accuracy, but should never destroy the larger form. One example he used was a scalloped column. The column was round, but was constructed of a series of convex forms. You must draw these convex shapes without losing the form of the round column. He sometimes referred to the column when explaining the drawing of the back. The vertebrae, the scapulas, the large and small muscles that allow us to bend and twist and lift are there, but these are all elements of a much larger shape.

As still life painters, we encounter forms with variations in shape. Modeling in the movement is a principle that can help us clarify these forms. Cylinders, spheres and cones all move from light to highlight, to light again, and then to halftone, shadow and reflected light. No matter how often or how complicated the interruptions of the form may be, this movement of values continues, and all detail must fit into the larger movement. The most beautifully painted details are of no use if they destroy the illusion of the shape of their host form.

Explain. Never confuse. Any detail on any surface, no matter how intricate or engaging, must follow the bigger form. Step back from the painting and make sure that no detail is more important than the larger form. If this happens, analyze the problem. Do details follow the values of the host? Do they follow the color temperatures? Does the drawing of the detail explain the form further, or does it confuse? Follow the sphere, follow the cylinder, follow the cone or cube. Whatever details you choose to include, follow the form.

HERITAGE ROSES
20″ × 20″ (51cm × 51cm) Oil on linen
Heritage Roses contains a good example of modeling in the movement. The Greek urn has small shapes that could easily destroy the bigger movement of the host form. The urn is round, and the smaller forms must be modeled to continue the round movement—never to interrupt it. Begin by first modeling the big round form and then add the carved details, staying within the major values of the host. This is more difficult to see in the shadow than it is to see in the light. In the shadow, you may be forced to use only reflected light to suggest the presence of the smaller forms.

Careful observation is necessary with a form like this. It is also helpful to step away from the painting often and to look at it from a distance to make sure you keep the smaller shapes within the major values of the form.

1. Model the Surface

This French Provincial antique pitcher is a rich yellow with a blue glaze casually poured over it. The dominant yellow of the pitcher is modeled first, establishing the temperatures of the light and shadow sides. The shadow is a mixture of yellow and black. The surface of this form is not smooth. For the light side, I use Cadmium Yellow Pale and Cadmium Yellow Light together, and do not overmix them. This achieves the mottled character of the surface.

2. Paint the Details

Warm the shadow by adding a bit more orange to the mixture. Add reflected light to the edge of the pitcher on the shadow side to lighten the edge and allow the form to turn away. The blue glaze is next. In addition to the values of the host form, the pattern must follow the temperature of the light and shadow as they move around the form from cool light to warm shadow. The light is an unmixed combination of Ultramarine and Cobalt Blue. Warm the blue as it turns to the shadow side. Use Rose Madder with Ultramarine Blue and add a bit of black. This mix is used for the shadows of leaves where they fall on the pattern of the pitcher, painted wet-into-wet; do not allow the yellow to dry completely before painting the blue. To create blue on top of yellow instead of mixing green, use plenty of paint for the blue glaze and a light touch of the brush. As the glaze drips down the pitcher, use less paint and a light touch to achieve soft edges where blue meets yellow. Add surface chips *after* the design. The highlight is last, white with a touch of Cobalt Blue.

Putting It All Together Step by Step

One of the wonderful things about still life painting is that you can change any shape to make it work the way you want it to. The choice is yours, whether it means bending or breaking the top of an onion; adding or subtracting a flower, stem or leaf; even modifying the color of an object to suit the painting. The objects in a painting are there only to serve the painting. The painting is a universe you've created, and you can change anything you wish.

LILACS AND COOL IRISES 28″×24″ (71cm×61cm) Oil on linen
The front edge of the table, draped by the white cloth, is straight. The bottom of the copper pitcher is a round form. The underplane of the pitcher reflects the white cloth, but forces the reflection to follow its own round form.

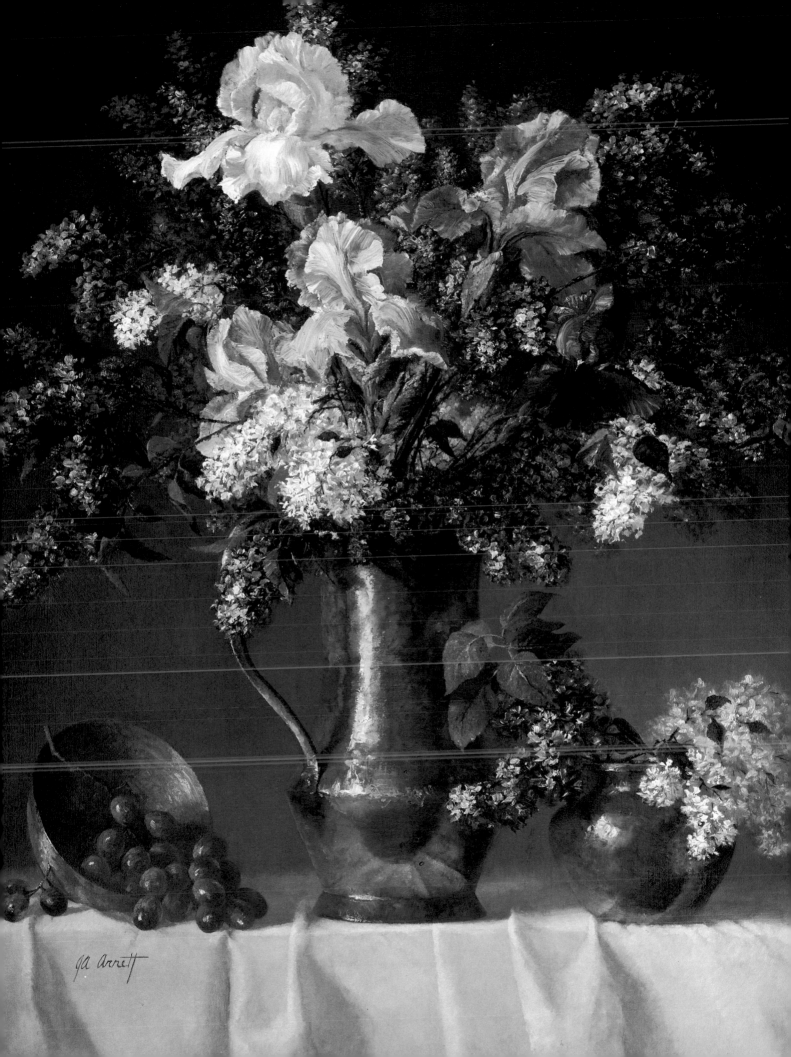

Lilacs and Orange Parrot Tulips

Taking Off Paint

After starting on this small canvas, I determined that the composition was not strong enough. By the time I made this decision, some of the paint was dry. I cleaned the canvas with a 1:1 mixture of turpentine and isopropyl alcohol (I use 91 percent isopropyl alcohol because rubbing alcohol is not strong enough). This mixture was poured over the canvas and allowed to rest for a few minutes. Then, I gently scraped the canvas with the blunt edge of an old palette knife. Good linen, properly primed and cured, will withstand this treatment. Be gentle when taking off old paint. Don't let the knife dig into the primer level. I began the painting again with a clearer direction in mind.

1. Locate Major Elements

I arrange the entire composition with parrot tulips, lilacs and smaller bicolor field tulips. Always make a quick sketch to locate the major elements. With only these few shapes, I already know the big shape of the composition and the location of the most important flowers.

2. Parrot Tulips First

I choose to paint the parrot tulips first because they are so temporary. Often, with flowers as complex as these, I first paint the entire flower with the shadow color, which results in a silhouette of the flower. With this flower, there are many tiny forms that have light and shadow. By painting the entire flower in the shadow color, you don't have to go back in and paint all these tiny shadow shapes: They are already there. Simply leave them alone and paint the lights over them. Not only is this easier, it is also more powerful and more believable.

Fresh Flowers

I keep a refrigerator in my studio with the temperature turned down. I keep my flowers there whenever I'm not specifically working on the flowers in a painting. This is especially helpful when working with flowers that change as quickly as parrot tulips, some of my favorite flowers. They are great teachers. They begin to open and change shape the moment you take them out of the cooler. They give you very little time to overthink what you're doing, and encourage you to react to them in a fresh and immediate manner.

3. Shadows, Lights and Local Colors

Shadows of the tulips are a mix of Cadmium Red and Rose Madder Deep. While wet, I paint the light sides of the tulips using a mix of Cadmium Red Orange and Cadmium Yellow Pale, being careful not to overmix the pigments. The light is from the left. The two tulips on the right are almost totally in the shadow created by the lilacs and the turning of the larger shape of the group of flowers. These two receive only a bit of light on the tips, where they escape the shadows of the other flowers. The local color of these flowers is varied and interesting. The petals have some yellow at their tips and a green stripe down the center of some of them. When painting these stripes, be sure to follow the value of the host form. Where the stripes are in the light, use a mix of Manganese Blue and Cadmium Yellow Pale for the green. Where the stripes are in shadow, use a mix of black, Cadmium Yellow Pale and Ultramarine Blue.

4. Begin Other Elements

With the most fragile flowers complete, begin the other elements. I paint the lilacs in their shadow colors first, establishing the large shape of the entire group and indicating the cone shapes of the individual lilacs. I treat the lilacs in the same manner as the parrot tulips. I paint each flower in its shadow color, both the purple ones and the few white ones. Because the lilac is composed of so many tiny petals, it is more believable to paint the shadow first and then stack the lights on top. This way, you don't have to go back in and find every tiny shadow shape. They are already there. I place the small field tulips and begin the negative shape of the background.

3. Add Green Background

The flat, simple background shape is added next. I use a green that echoes some of the greens in the cabbage and the onion tops to be added later. Green and purple is one of my favorite color combinations. It occurs naturally in the cabbage itself and in many of my favorite subjects, including lilacs, with their bright green leaves. Nature is truly a wonderful colorist.

4. Model Remaining Elements

The copper cup and small yellow-white onions are painted with extreme contrast and fine detail to bring them forward. The movement of the onion tops brings the eye in and up to the center of the cabbage. The dark red onions and the small yellow-orange onion do the same. Their tops add interesting details and movement to the painting and continue to lead the eye back to the cabbage. I break and twist the tops of all the onions to better serve the composition of the painting.

KING CABBAGE
14" × 18" (36cm × 46cm) Oil on linen

Eterne

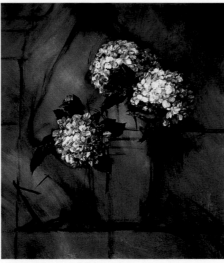

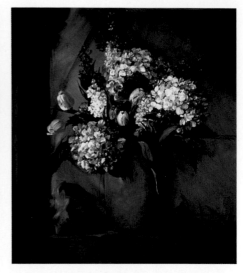

1. Indicate Major Elements

I begin by locating the center of the canvas; you can see the vertical and horizontal lines where they cross in the middle. I then loosely indicate the location of the major elements: the column, urn, big triangle of the overall shape of the flowers and location of the three hydrangeas.

Explore Different Settings

Eterne and *Spring, Seillans* (pictured on page 107) are good examples of similar subjects painted in dramatically different environments. *Eterne* has a more traditional dark background; *Spring, Seillans* has a bright French village as a background. It is possible to achieve dramatic effects with both dark and light backgrounds.

2. Hydrangeas, Wet-Into-Wet

Because the hydrangeas are such important elements, and because they have a shorter life than other elements, I choose to paint them first, taking them to a finished state. These flowers have to be dramatic in every way if the painting is to be successful. Another reason to finish them right away is to paint them wet-into-wet. Paint each hydrangea as a sphere, using only its shadow color and relatively thin paint. Stack the lights on top of this, allowing shadow color to show through where there are tiny spaces between the petals. This is easier, more believable and far more fun than trying to go back into the light areas and pick out tiny shadows later.

Learning to paint wet-into-wet shouldn't frighten you. The lights on these flowers are painted with very thick paint. Use more pressure on the brush to pick up paint where you wish to underneath, and a very light touch where you wish to leave the paint underneath undisturbed. The thick paint on your brush will help you do this. The wet paint also allows you to slightly soften edges as the sphere of the flower curves away from the foreground. This softening of edges is accomplished by dragging the edges of forms together with a light touch of a clean brush.

I choose to paint the hydrangea leaves at this stage for two reasons: They are the most dramatic darks in the composition, and they also have a very short life, beginning to droop and curl quickly.

3. Lights And Shadows

With the hydrangeas and their leaves finished, I can slow down a bit. I block in the major lights and shadows of the column, urn, conch shell and pomegranate. I resist painting the back wall of the niche at this time because I'm not completely sure of its exact value. It will be dark, but I'm not sure just how dark. I decide to finish the remaining flowers before making that decision. I paint the tulips, the stocks and their leaves, following the large triangle shape of the bouquet.

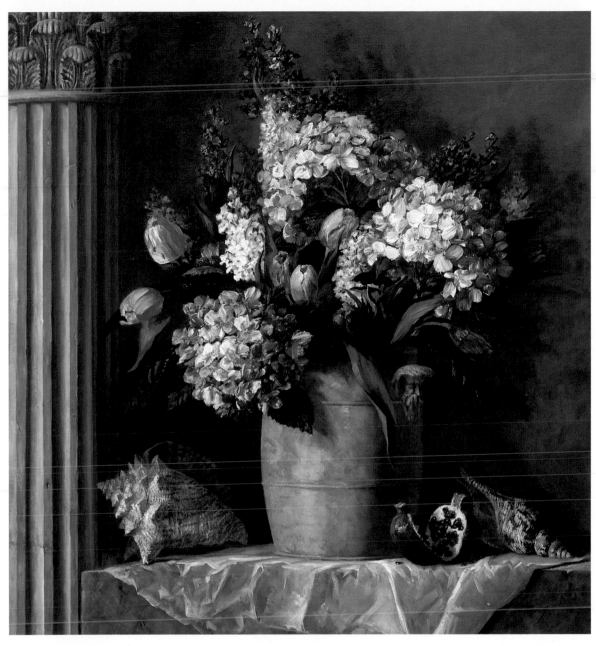

4. Final Details

As I begin painting the niche behind the flowers, I see that the environment for the flowers is too strong in color. I change the color of the stone, the column and the urn to a more neutral hue, one that does not compete with the vibrant colors of the flowers. I add a few more stocks and one additional tulip to the composition, all in shadow. The cast shadows of the column, flowers and urn add interest to the background without stealing attention from the flowers.

Seashells are prime examples of modeling an extensive pattern without losing the larger form of the host. You must be sure that the pattern and all the tiny details care-fully follow the values and color temperatures of the larger shape.

The pomegranate is associated with spring, or growth, in Greek and Roman mythology. Proserpine, daughter of Ceres (the goddess of agriculture), was stolen by Pluto (the god and ruler of the underworld) to become his wife. Ceres, in her grief, denied her favors to the land. The gods decided to allow Proserpine to return, providing she had eaten nothing while in the land of Pluto. She had eaten a few seeds of the pomegranate, so a compromise was made. She was to spend half the year below with her husband and half above with her mother. The compromise was accepted by Ceres and she re-turned her favor to the land. When Proserpine is with Pluto, we have winter; when she is with her mother, Ceres rejoices and we have spring and summer. Thus, spring returns after winter eternally.

ETERNE
31″ × 29″ (79cm × 74cm) Oil on linen

Choose a Theme

Some of the paintings I choose to do have specific themes. This one is about spring and the promise of its eternal return.

Spring, Seillans

Still Life and Landscape

For a time, I resisted combining still life with landscape. The two were taught to me by different teachers, excellent in their own fields, who seldom agreed with each other's theories. Another reason I avoided the combination was a bias against backlit subjects. Many contemporary paintings set against a window are lit from behind the subject. I prefer a single light entering the painting from one side. During our travels, I discovered a desire to include landscapes in my paintings, but kept tripping over theory and light source. I decided to paint the still life as I normally would, with the light entering the painting from one side. The landscape is designed to work with the still life elements, concentrating on aerial perspective, careful to maintain the same direction of the light as that in the still life foreground. While studying Italian portraits of the Renaissance, such as Leonardo da Vinci's *Mona Lisa* ("La Gioconda," c. 1500), I found the contradictions had been resolved 500 years ago. In the *Mona Lisa*, light enters the painting from the left; the landscape behind is also lit from the left. On a trip to Florence, I observed this same light over and over again in portraits and religious paintings. To paint portraits or still lifes against a landscape background, you do not have to backlight your subject.

This photograph is of a small part of Seillans, a lovely village in southern France. We have been there several times and usually rent a house overlooking the village. I chose these houses for the background for my spring flowers. The remainder of the buildings in the painting can be seen from the same location, but I moved them a little closer to the houses. As painters, we have this freedom. In fact, it may even be our responsibility. We must design the entire canvas to suit our purpose. If you must move a monastery or a mountain to create a stronger painting, move it.

1. The Big Shapes

For the environment of my painting, I choose an arched stone window, high above Seillans. First establish the big shapes. The position of one side of the arch and its base are important. If they are too wide, they will dominate the still life; too narrow, and they will look insignificant. The elements on the table and the pitcher are placed with very simple, quick strokes. You need to know just how bright the sky will be in order to judge values in the rest of the painting. Then establish the large dark mass of the flowers so that you can pull individual forms out of the larger mass. You still want to keep the colors of the flowers fresh and unmuddied, so use the shadow colors of the flowers to indicate their positions.

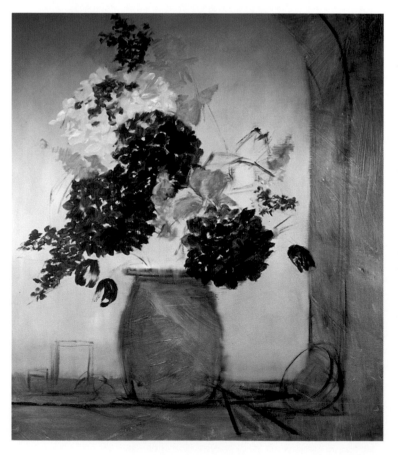

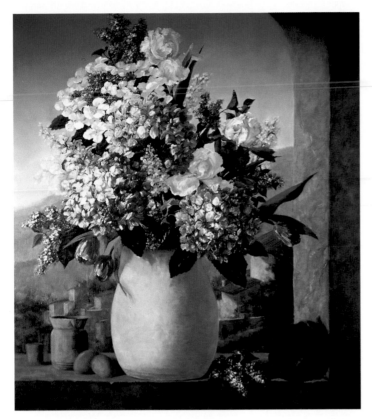

2. Foreground and Background

With the shadow colors still wet, apply the lights to the flowers with rich impasto strokes. Finish all of the flowers and leaves first because these elements have the shortest life. I enjoy finishing a flower once I have started it because I want to avoid the labored look that worked-over flowers can develop. If you keep colors and brushwork fresh and spontaneous, you will find that your flowers look fresh. Establish shadows and lights in the remaining foreground elements, leaving most of the detail for the next step.

Distant hillsides, buildings and walls come next. With the foreground firmly established, it's much easier to judge the values of the elements in the background.

3. Final Touches

Details are added last. See pages 48 and 49 for a discussion of painting the spheres of the hydrangea and bird's nest. See pages 86 and 87 for a discussion of painting the details on the large pitcher. The pattern on the large pitcher, and the modeling of the small green pitcher, eggs and bird's nest, are carefully painted, making sure details never become more important or obvious than the host forms.

Bring up landscape values a bit. Make hillsides and buildings lighter. Simplify some shapes of the buildings and add just enough detail to make them interesting. Things that help forms come forward in the picture plane—bright colors, extreme contrasts, sharp edges and fine details—are reserved for the still life.

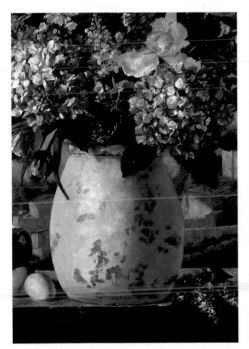

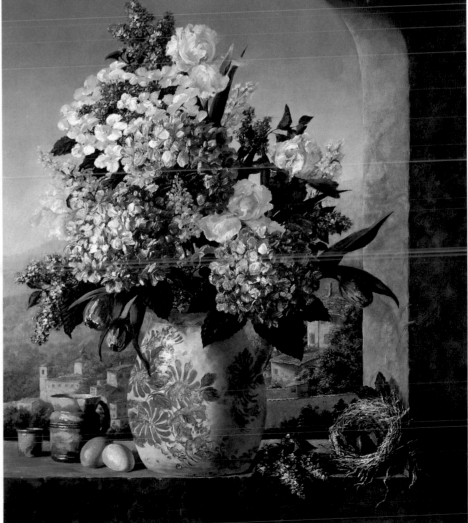

A Final Check

Turn your finished painting to the wall, and later look at it with a fresh eye, checking everything again. Is the composition exciting? Are values correctly judged? Are the temperatures of the colors correct? Is the drawing correct? Do you like the painting?

Radishes and Zinnias

1. Position Large Elements

I divide the canvas with grid lines, finding the horizontal and vertical centers first. This helps me decide where to place the major elements. I then indicate these positions very loosely, locking myself only into the placement of large elements, and ignoring, for a time, all of the details.

2. Radish Leaves and Shadows

Radish leaves have many tiny light-and-shadow shapes. Because of this, I decide to use the same technique used with complicated flowers. Paint the entire shape of the cluster of leaves in the shadow color, a mixture of black, Cadmium Yellow Pale and Ultramarine Blue. With this one simple step, I have now painted all of the tiny shadows, saving myself from having to go back in and pick out these small shapes later. Wet paint underneath the lights allows you to drag wet edges together wherever you wish. Lights are painted after the large shadow form is established. I use a bright, spring green made of Cadmium Yellow Pale and Manganese Blue with a light touch of the brush in order to leave the wet shadow beneath undisturbed, unless I want to drag the two colors together. Don't change color to do this, just the pressure of the brush. A little extra pressure mixes the wet paint of the shadow below with the wet paint of the light on top, accomplishing a halftone or a soft edge with no trouble at all. Highlights on these feathery leaves are stacked on with thicker paint, using a simple mixture of white and a little Ivory Black. Leaves that come forward over the front of the table are painted with very crisp edges.

Shadows for both the red and the purple radishes are painted with a mixture of black and Cadmium Red. The shadows of the two white radishes are painted with a mixture of Ultramarine Blue, Yellow Ochre and white.

3. Lights on Radishes

The radishes have begun to dry out by this time. I lightly spritz them with water from a small spray bottle.

This bunch of radishes from the farmers' market contains a wonderful variety of color. I selected them because I want to paint the radishes and the zinnias in the same hues. The zinnias come from my own garden, so I knew there were a wide variety of color choices right outside the studio door.

The light sides of the red radishes are painted with Cadmium Red plus Rose Madder, dulled with a tiny amount of Naples Yellow. For the few paler red radishes, I add Permanent Rose and lift the value further with additional Naples Yellow. The purple radishes share the pink tones. I paint them with a purple made by mixing Permanent Rose with Ultramarine Blue, and then add a small amount of white.

The white radishes are not a pure white at all. I mix Yellow Ochre with white for the light sides of these.

Try Something Different

All grapes aren't the same. There are many varieties. They are all different in color and shape. The grapes in this painting are smaller and less translucent than others. Study the variety selected for your painting. It is tempting to paint a subject the same way every time. This results in a formulaic look to your work. Look with fresh vision each time.

4. Finish Radish Details

Because of their short life, I decide to finish all the radish details. Some radishes have circular lines toward the root end. This detail helps add movement and dimension. These circles, drawn around the radish, enforce the shape. I use Raw Umber mixed with white to paint them. This mixture is also used to paint some of the imperfections of the radishes. The highlights are added next, painted with white plus Cobalt Blue.

Notice the tiny reflections in the shadows of the white radishes, created by the purple of the radishes next to them. I paint these cautiously, not wanting to call too much attention to them.

The thin parts of the radish roots are first painted in their shadow color, black plus Cadmium Orange and Yellow Ochre. There are a few places near the body of the radishes where the root assumes more of the local color of the radish. The red or purple seems to bleed down the thin part of the root. The light, a mixture of white and Naples Yellow, is stacked on top of this shadow. It is easier to paint the shadow first and then stack the light on top rather than to paint them separately, trying to force these two tiny edges to meet. This is a wonderful technique to use when painting tiny details. Do this with most of the very small details in your paintings.

When you paint the light sides of these tiny roots—or any tiny detail such as a branch or the stamen of a flower—use thick paint. Stack the paint on only the tip of the brush and then "put" it down, don't stroke it on. The difference in the two approaches is dramatic. Try it.

5. Develop Other Elements

There are three different flowers in the basket: giant zinnias, miniature zinnias and a new sunflower hybrid that is burgundy with pale yellow at the tips of the petals. All of them are variations on the basic disk shape. For all of these flowers, I use the same technique as I did with the radish leaves, painting each flower in its shadow color, and then stacking the light on top of the still-wet shadow.

I finish the simple, flat background and two pieces of antique French pottery. I further develop the basket by painting the entire form in its shadow color. It would be so difficult to paint every tiny shadow and every light separately in this finely woven basket. With the shadow already painted in one big, simple step, you eliminate the need to go back and pick out all the small shadow shapes later.

A Fresh Look

Radishes and Zinnias, like *King Cabbage*, contains elements that last only a short time. Radish leaves, once out of the cool, wither quickly. Grape leaves give you even less time. There are some passages that are painted very quickly to achieve the fresh look I want. Use "stand in" radishes and grape leaves to compose the setup. If you work with flowers, vegetables or fruit that last only a short while, buy backups.

6. Grapes and Basket

Before I paint the light on the basket, I paint the grapes, their leaves and their stems. I also quickly paint the cast shadows of these forms on the basket. The form shadow of the grapes is painted with Cadmium Yellow Pale plus black; lights are this same mixture cooled with white. Highlights are quick, thick strokes of white mixed with a tiny amount of Ivory Black. Where light passes through a translucent grape, the transmitted light is painted with Cadmium Yellow Pale. All this is painted wet-into-wet, gently dragging the wet paint of the light and shadow edges together.

Finish leaves and grapevine in one sitting. Shadows are black plus Cadmium Yellow Pale with Ultramarine Blue. Lights are this same mixture cooled, and their value is lifted with white. For subtle highlights on the leaves I mix white with Ivory Black and float this silvery white over the light beneath.

The basket is another good example of painting a complex pattern while maintaining the integrity of the larger form. First, find the vertical ribs of this complex basket, which consist of several reeds. As the basket turns away, notice that the ribs are painted closer together. The ribs are now your guidelines. The horizontal weave is not difficult. It just takes time and concentration. The weave travels over one rib and under the next, following the shape, values and color temperature of the basket.

Finally, turn the painting to the wall for a few days. When you look at it again, you may see things you wish to alter, strengthen or make weaker. Have confidence in your work, but never be afraid to change something for the better.

RADISHES AND ZINNIAS
20″ × 24″ (51cm × 61cm) Oil on linen

Sunflowers Over Peillon

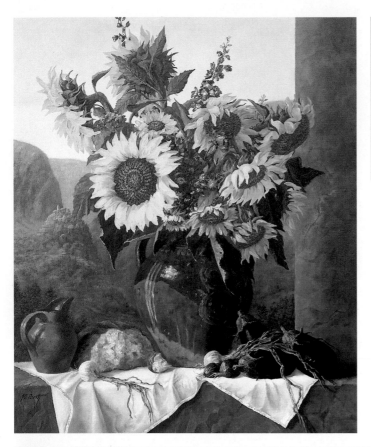

Background and Foreground

The more interesting the background, the stronger the foreground must be. I consider this at the very beginning of a painting when selecting elements.

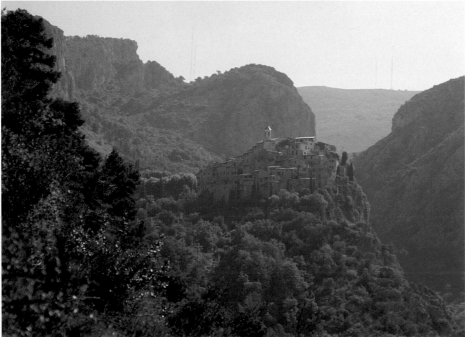

Peillon, a lovely village in southern France, inspired the background of this painting. Compare this photograph with the landscape in the finished piece and you will see that creative license is taken, changing the scene to work with the design requirements of the still life. The photograph of the village is shot with the sun high in the sky. In the painting, the sun is lower, creating more of a side light for the village and mountains. This is necessary to work with the source of light in the still life. If you decide to use a landscape background, be sure that the light of the still life and the light of the landscape enter the painting from the same direction.

1. Tone the Canvas

This is a photograph of the canvas prepared for *Sunflowers Over Peillon*. Even though a painting may have a landscape with a bright sky in the background, tone the canvas as you normally would for any still life. This canvas is toned with a mixture of Ultramarine Blue and Burnt Sienna, brushed on with a small amount of medium and then wiped down to remove obvious brushstrokes, making sure there is an even, thin coat of paint in a middle value. Use a nylon stocking to wipe the canvas: The nylon leaves no lint behind, as a rag or paper towel might. I usually choose to leave the canvas in this mottled state. There is no profound technical reason for this; I simply like to begin this way. It somehow takes some of the fear away for me. This surface already looks artistic, and any marks made on it will look good from the start. Allow this to dry before beginning the painting. If the background landscape were to be a more important element in the painting, I might choose to tone the canvas in a neutral gray at a slightly higher value.

2. The Big Shapes

I quickly block in the very large areas: sky, mountains, shapes of walls and the ledge. The still life elements on the ledge are treated almost as one strong shape. The blank areas are simply notes to myself, reminding me where to place the distant village and some of the most important flowers in the composition. You want to be satisfied that the canvas is comfortably divided into the very large shapes before you continue.

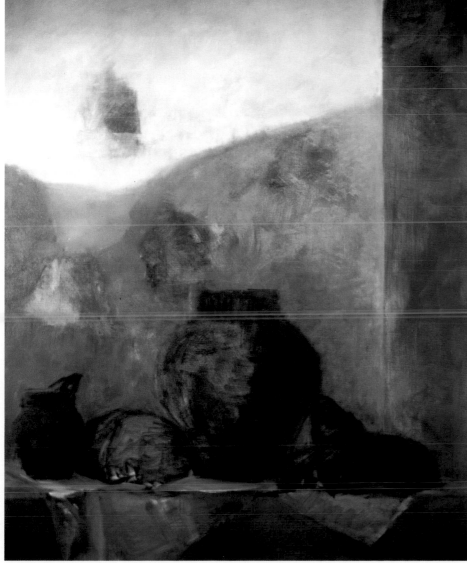

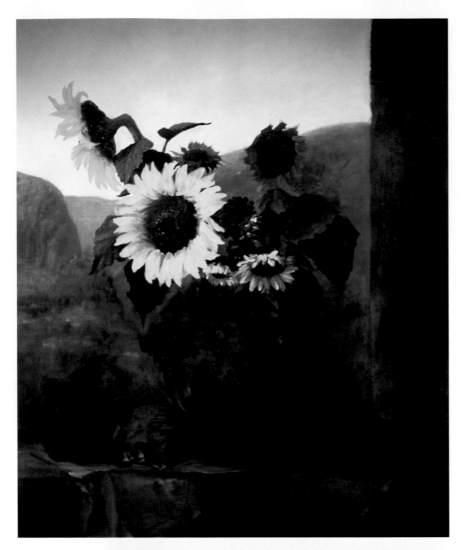

3. Develop the Flowers

I mix shadow color for all of the sunflowers by combining black with Cadmium Yellow Light and a touch of Cadmium Orange. For the color of sunflower petals in the light, I use Cadmium Yellow Light with bold impasto strokes. The highlights are placed with pure Cadmium Yellow Pale. In this composition, the large sunflower on the left is the star of the show. I paint it first. Because the disk of this sunflower is almost directly facing the light, it has only a little shadow where the petals curve in toward the center. There are a few petals that are in the cast shadows of other petals.

When painting sunflowers, be courageous. Put the paint down with energy and try to leave it alone. This is hard. The temptation to go back, model and pick at it is powerful. Just think about how strong the sunflower really is, and try for that feeling.

Look at the sunflowers just begun at right. You can see how I paint the shadows first. The light is then stacked over the wet shadow.

The large sunflower leaves are very important in this composition. I turn most of them away from the light so that they serve as strong dark shapes. These dark leaves and the other darks in the foreground help separate the still life from the paler green trees and mountains of the landscape beyond. The still life is strong enough at this point to begin painting more of the landscape and other flowers.

4. More Flower Values

I finish most of the sunflowers and their leaves, then begin to add more of the zinnias and the delphiniums. Notice that I do relatively little to the centers of the sunflowers at this point. With their value established, the tiny details of the seeds in the center can wait.

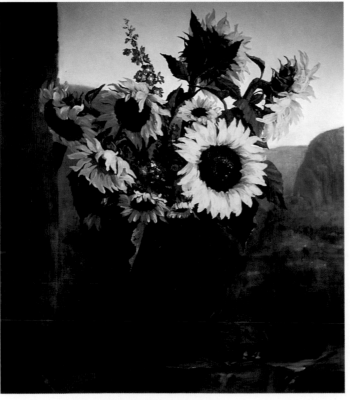

5. Make Final Decisions

I add a few more zinnias and delphiniums, allowing one of the delphiniums to exit the top of the canvas; this subtly leads the eye down to the sunflowers. Develop the remaining foreground elements. The vase and eggplants are strong shapes with dramatic, dark colors. The small pitcher on the left is a simple shape, and the spout directs the eye up to the main sunflower. The bread is also a very simple shape with strong textures. The bright white cloth on the ledge provides extreme contrasts with the dark objects on the ledge. The onion tops are painted in extreme detail, with crisp edges, and are placed to come forward over the edge of the ledge, creating the illusion of occupying the space *in front* of the ledge.

At this point I finish the circular pattern of the sunflower seeds. Do not assume, once you have painted a few sunflowers, that you know the formula for this pattern. None of the varieties are exactly the same. You must look carefully each time to determine the pattern. Remember, like all patterns on larger forms, you must follow the value and temperature of the host form.

Near completion of a painting this complex, you'll probably be concentrating on the final details. You must keep in mind at all times, however, that you are working on the entire painting, judging every element against every other element. Is everything as strong as it should be? Is the atmosphere working as hard as it can? Do the large spaces work? Do the tiniest details perform their function properly? Ask yourself these questions and more. Take time to look at the finished painting. Look with a critical eye. I decide to slightly raise the value of the background mountains yet again.

You are always in charge. Change anything you wish to make the painting stronger. Put the painting away for a day or two, and then look at it again. Check everything. Your painting is your vision—your statement. It is a part of you. You want it to reflect the best part.

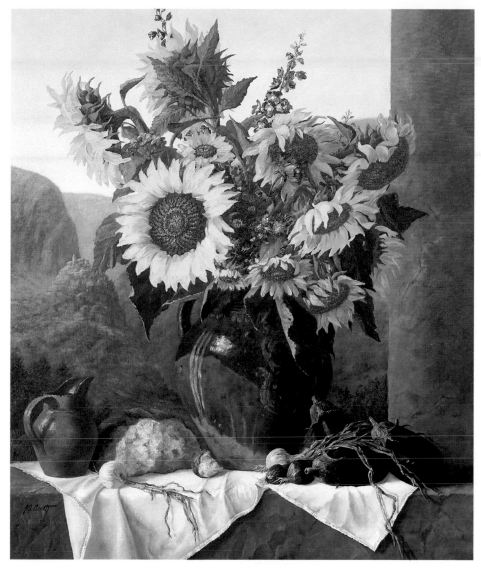

SUNFLOWERS OVER PEILLON
36″ × 30″ (92cm × 76cm) Oil on linen

Think About It

This is the time in a floral painting when you face the most difficult decision of all. When do you stop adding flowers? It is much easier to continue adding flowers than to stop. My best advice to you is to stay focused. Make these final decisions slowly. Anything that enhances your idea should remain in the painting. If it isn't part of the idea, if it doesn't accomplish something specific, leave it out.

Fall Harvest

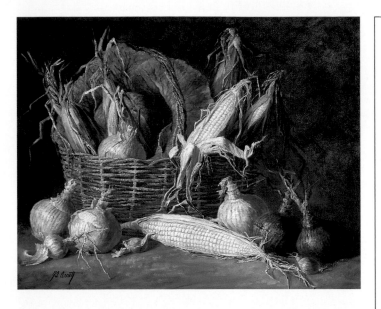

An Abundance of Subjects

Fall is a wonderful season for the still life painter. All of the farmer's efforts are available, waiting for us to choose from the abundance. Fresh corn, cabbages and onions are among my favorite subjects. Corn is so co-operative: You can leave the husk on or pull part or all of it away from the cob to create a wonderful variety of designs. For this painting, I pulled the husk away from three of the ears and left the rest covered. The husks are stiff and will twist and turn any way you want. When I was setting up this composition, I pulled the husk of one of the ears of corn over the edge of the basket. This created a playful, entertaining form that added excitement and extra dimension to this bright element in the painting.

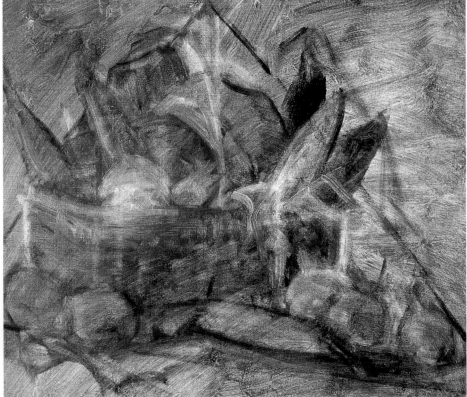

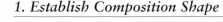

1. Establish Composition Shape

First establish the entire shape of the composition. All of the elements of the painting are indicated loosely, concentrating solely on their location in the painting. This is the time to make sure your composition fits comfortably on the canvas. This is the best time for changes in composition, if necessary.

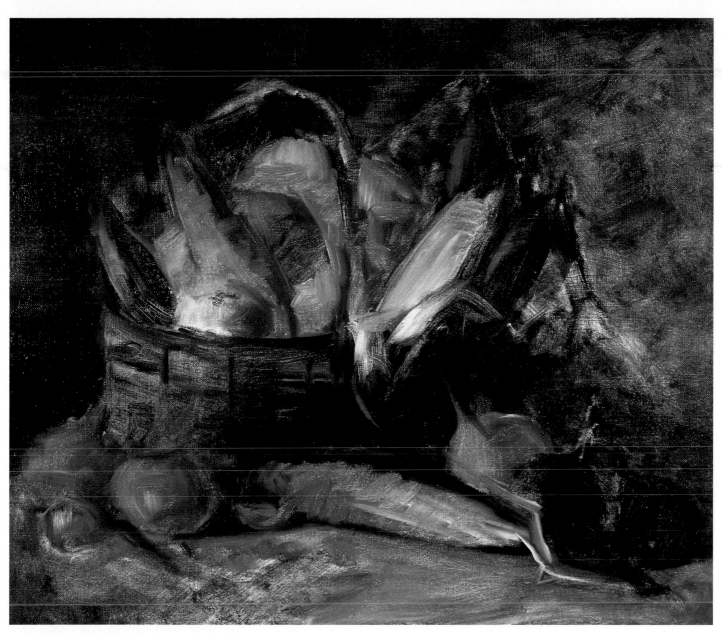

2. Background, Shadows and Lights

State the background shape. Next, paint the shadows of all of the elements, keeping them loose. I indicate some of the lights on the vegetables, just to reassure myself of the correct positions of these strong elements.

3. Develop Individual Elements

I strengthen shadows of all the elements and begin to paint the major lights on the vegetables. I paint some detail here, but the majority of the small forms are added later, after the corn is finished.

At this point, the two most important ears of corn and the cabbage become priorities. The corn with the husk pulled back will soon begin to dry, and the fresh cabbage will wilt, so I decide to finish these before going on to the other, longer-lasting elements.

You can see the green of the outer cabbage leaves. I overstate this green at first, knowing that I will stack some purple there later. The cabbage assumes more of its purple color nearer the center.

I paint the shadows of the cylinders of all of the corn with a mixture of black, Cadmium Yellow Pale and Ultramarine Blue. For the inside, I choose to paint the entire shape in the shadow color of the kernels, a simple combination of black and Cadmium Yellow

Pale. By painting all of the shadows of all of the kernels at once, I will not have to go back later and painfully pick out each tiny individual shadow.

For the curling husks of corn, I paint the shadows with the same mixture used for the cylinders: black, Cadmium Yellow Pale and Ultramarine Blue. For the light on these forms I use Manganese Blue, Cadmium Yellow Pale and white without overmixing the pigments. These arabesque forms are painted with impasto and left unblended. Place the thick, luscious paint down and leave it.

I solidify the remaining ears of corn, painting their light sides with a mixture of Manganese Blue and Cadmium Yellow Pale applied unmixed with impasto strokes. I also begin to paint the light on the onions. For the texture, I use short horizontal strokes, suggesting the veins of the onions.

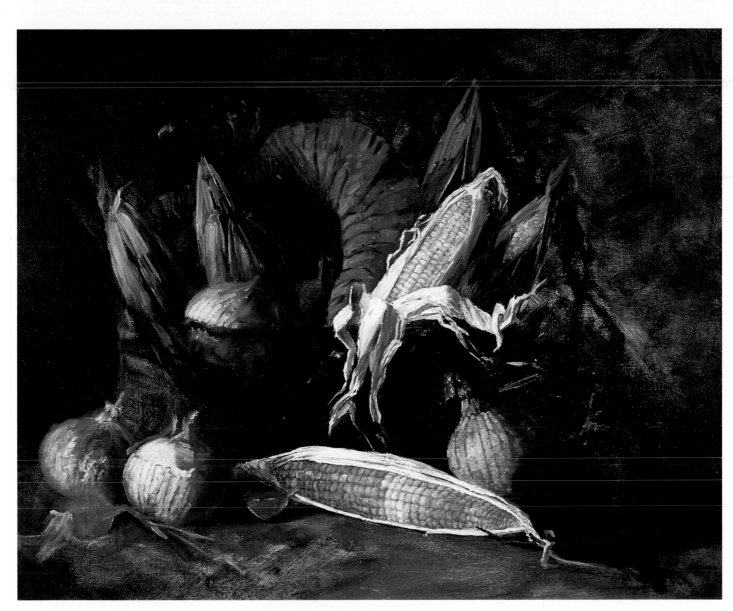

4. Model Corn Kernels

Study these rows carefully. For a discussion of painting these trans-
lucent kernels, see pages 80 and 81. The lines are not mechanically
straight. Capture these imperfections; you will achieve a much more
natural and realistic feeling than if you paint them perfectly straight.
Into the still-wet shadow, I paint each kernel with Cadmium Yellow
Pale mixed with white, leaving the shadow beneath exposed where
the kernels turn away from the light. I am too tentative with this
step at first, and realize that the kernels must be much brighter. I
simply paint them again, brighter this time, but with the
same color mixture. All of this is done wet-into-wet.

5. More Corn and Cabbage

I continue to paint the bright light on the kernels of corn. The rows of kernels have two movements: vertical, down the long axis of the corn, and horizontal, circling around the form. Both movements help describe the shape. Step back and study the cylinders often. This is an example of modeling in the movement. The details must follow the bigger movement in value, color temperature and drawing.

Lights and details of the cabbage are finished next. The light on the head of the cabbage, a simple sphere, is painted with a purple made by mixing Rose Madder, Ultramarine Blue and white. Nature did not overmix these colors; follow her lead. A small amount of this purple mixture is dragged over the leaves closest to the center of the cabbage.

The cabbage head highlight is white cooled by adding just a touch of this purple mixture. This same frosty highlight is used on the purple areas of the outer leaves. Where the outer leaves become greener, I change the highlight to white plus Manganese Blue.

The cabbage leaf veins are lines that can help describe the form they follow. I use Rose Madder with just a touch of Ultramarine Blue to paint them.

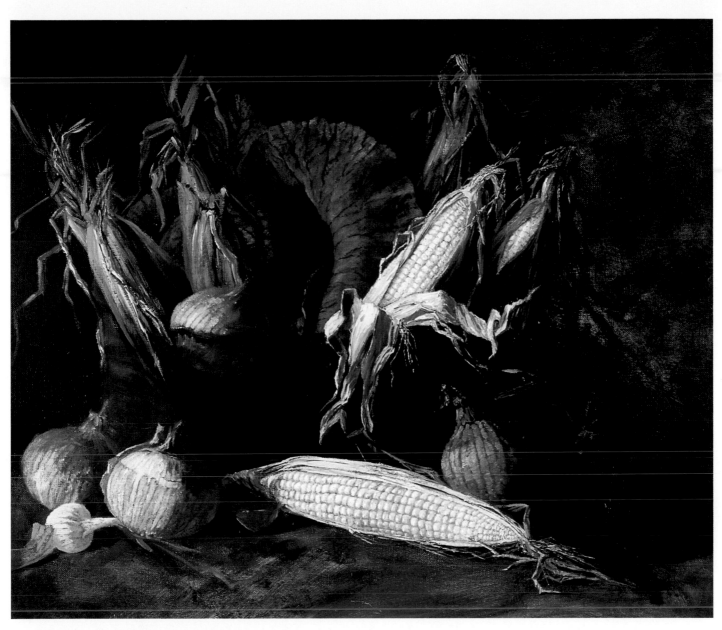

6. Finish Corn and Continue Onions

The patient onions and basket continue to wait while I finish all the corn details. The highlights are painted with pure white impasto touches. Where the turning of the corn cylinder permits, I paint the transmitted light exiting the juicy kernels. I use quick, unblended strokes of Cadmium Yellow Pale.

I begin to paint final onion details next. Onions are another very cooperative vegetable. Always shop for the ones that still have a lot of onionskin. This permits you to choose the color you want and even to design shapes to some degree. Where you want a brighter green-white, pull the onionskin back. Where you want a darker color, or perhaps a bit more orange, leave the skin on, or pull it back only partially. For this painting, I leave most of the onionskins on, preferring the oranges and umbers this allows me to paint, leaving the brightest color for the corn kernels. So, what color do you paint a yellow onion? That depends on what you have chosen to do with it. If you choose to pull some of the onion skins off, keep these around. They can be delightful compositional devices.

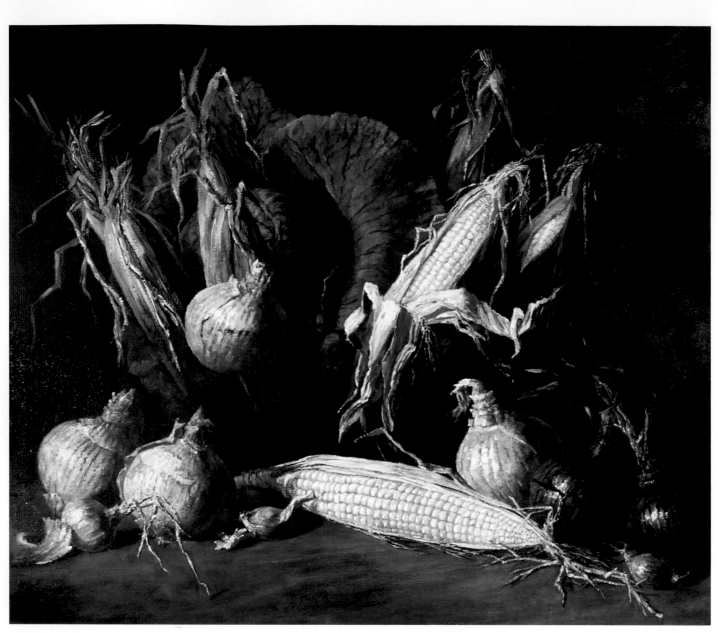

7. Vegetable Details Finished

Look at the strange floating onion at left. There is a good reason for this. The basket
chosen for this painting is a country basket constructed of a very rough weave. I wasn't
sure just how much of the objects inside would be left to show through the weave. It's
easier to paint the objects inside the basket first, then paint the weave of the basket over
them. This is an even better idea with a very open weave basket. It's much more difficult
to paint back in between the weave than it is to do this work first.

8. Begin the Basket

By this time, all the vegetables are dried, their former freshness and vitality only a memory. The basket is the final element. In this step, you can see the construction lines used to draw the basket (also see page 40). I construct a simple rectangle in two-point perspective, then round the sides a bit. I draw the vertical ribs of the basket also. To locate the center of the long side of the basket, I draw diagonal lines from corner to corner. The point where these diagonals cross is the center and the proper location for the handle of the basket. A drawing of the "X marks the spot" geometry is in the discussion of linear perspective on page 40.

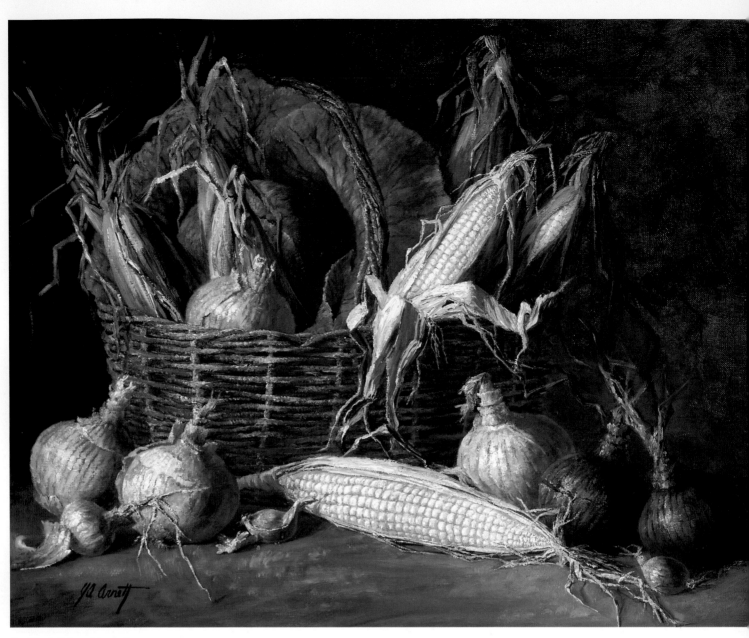

9. *Finishing Touches*

At this point, the basket requires patience and focus. The vertical ribs were located in the previous step. For the horizontal weave, there is just no shortcut. Pick one reed and follow it around the basket, over and then under each rib. Make sure this first horizontal follows the values, color temperatures and shape of the host form. This one now becomes your guide for all the rest. Take frequent breaks and check to make sure that the details do not become more important than the larger form.

Finally, put the painting away for a few days. Look at it when you are fresh and the pain of weaving the basket is a memory. Be your own toughest critic. I decide to take out some of the corn silk added to the ear of corn on the table: It is distracting. If the painting meets your goals and is the dramatic statement you wished to paint, it is time to sign it.

FALL HARVEST
18″×22″ (46cm×56cm) Oil on linen

VANITAS

13″ × 18″ (33cm × 46cm) Oil on linen

No discussion of still life painting would be complete without a discussion of a vanitas painting. The vanitas is a very old and honored genre. Its original message was meant to be a warning about the temporal values of the vanities of life. Beauty (the flowers), knowledge (the books) and time (the burned candle) are temporary and all life ends the same way (the skull). The message was, "Behave now, this all ends. After that, only the real and lasting values count."

While I believe this is true, I would like to add one very important point. Enjoy now. Don't put it off. Painting is a joyful, fulfilling experience. It can give you peace of mind. It can seem to make time stand still. It can give you a sense of accomplishment. I personally believe it can contribute to your health. In my life, painting has brought happinesss. I believe it can do that for you too.

Index

More Great Books for Oil Painters!

Painting Expressive Portraits in Oil—Breathe life into your subjects! Professional portraitist, Paul Leville, offers step-by-step instruction on painting realistic likenesses of men, women and children—from creating proper proportion to perfect skin tones. #30918/$27.99/128 pages/239 color illus.

Painting Flowers the Van Wyk Way, Revised Edition—Helen Van Wyk's artistic legacy lives on through her proven talent for painting vivid floral compositions. Now, easy-to-follow instructions give you her tips and techniques for painting flowers of all kinds, regardless of skill level. #30954/$27.99/128 pages/230 color illus.

Your Painting Questions Answered From A to Z—Discover oil painting instruction at its finest! In her crystal-clear teaching style, renowned instructor Helen Van Wyk answers hundreds of the most-asked questions spanning her 40-year teaching career. #30933/$16.95/198 pages/125 illus./ paperback with vinyl cover

Oil Painting Step by Step—Master the medium of oils with this unique series of painting projects. Using this powerful teaching guide, you'll start with the foundational skills and work your way through more complicated techniques and lessons. #30879/$22.99/144 pages/300+ color illus./ paperback

Fill Your Oil Paintings With Light & Color—Create vibrant, impressionistic paintings as you learn to capture light, color and mood in oils! Simple demonstrations help you learn the methods you need to create rich, powerful paintings. Plus, you'll find a showcase of finished works that's sure to inspire. #30867/$28.99/144 pages/166 color illus.

Creative Oil Painting: The Step-by-Step Guide and Showcase—Get an over-the-shoulder look at the diverse techniques of 15 master painters. You'll watch and learn as they use innovative methods and step-by-step projects to create gorgeous landscapes, still lifes and portraits. #30943/$29.99/144 pages/250 color illus.

First Steps Series: Painting Oils—Discover everything you need to know to start painting with oils right away—from tools and materials to how to put "the right color in the right spot." 12 step-by-step demonstrations and quick, easy "Painting Primer" exercises will have you creating your first still lifes and landscapes in no time at all! #30815/$18.99/128 pages/96 color illus./ paperback

Oil Painting: Develop Your Natural Ability—Learn the building blocks that lead to excellent oil painting! You'll study 36 step-by-step exercises designed to take you through one important concept at a time—from creating preliminary sketches to evaluating your work objectively. #30818/$23.99/128 pages/220 color illus./ paperback

Romantic Oil Painting Made Easy—Create sensitive, impressionistic paintings with guidance from internationally acclaimed oil painter Robert Hagan. No matter what your level of experience, you'll be able to create enchanting paintings almost immediately by using Hagan's unique "placement theory" and simple color system. #30894/$29.95/96 pages/400 color illus.

How to Get Started Selling Your Art—Turn your art into a satisfying and profitable career with this guide for artists who want to make a living from their work. You'll explore various sales venues—including inexpensive home exhibits, mall shows and galleries. Plus, you'll find valuable advice in the form of marketing strategies and success stories from other artists. #30814/$17.99/128 pages/paperback

Oil Painting: The Workshop Experience—Get all the benefits of the workshop experience without the inconvenience and expense of travel! With this unique workshop in print, you'll receive one-on-one instruction from artist Ted Goerschner as he shows you his secrets to fresh, bright color and techniques for painting outdoors. #30709/$28.99/ 144 pages/174 color, 13 b&w illus.

Becoming a Successful Artist—Turn your dreams of making a career from your art into reality! 21 successful painters—including Zoltan Szabo, Tom Hill, Charles Sovek and Nita Engle—share their stories and offer advice on everything from developing a unique style, to pricing work, to finding the right gallery. #30850/$24.99/144 pages/145 color illus./paperback

100 Keys to Great Oil Painting—Find great advice on everything from selecting paints and brushes to harmonizing colors and displaying finished works. Plus, special sections offer advice on how to use oils to paint landscapes, portraits and cityscapes. #30728/$16.99/64 pages/color throughout

How to Capture Movement in Your Paintings—Add energy and excitement to your paintings with this valuable guide to the techniques you can use to give your artwork a sense of motion. Using helpful, step-by-step exercises, you'll master techniques such as dynamic composition and directional brushwork to convey movement in human, animal and landscape subjects. #30811/$27.99/144 pages/350+ color illus.

Painting the Beauty of Flowers With Oils—Create graceful florals using traditional, time-honored methods. Clear and friendly instruction covers everything from choosing subjects to painting troublesome parts of a still life. Step-by-step instructions show compositions in progress. #30666/$22.99/144 pages/195 color, 18 b&w illus./paperback

The North Light Artist's Guide to Materials & Techniques—Shop smart with this authoritative guide to buying and using art materials in today's most popular mediums—from watercolor, oil and acrylic to charcoal, egg tempera and mixed media. You'll find personal recommendations and advice from some of North Light's most popular artists, as well as informed discussions on basic techniques, shopping lists, paints, surfaces, brushes and more! #30813/$29.99/192 pages/230+ color illus.

Color Mixing The Van Wyk Way: A Manual for Oil Painters—Learn how to put color theory into action! You'll see how to paint any subject with the six basic colors plus white and gray. Van Wyk makes the frustrating task of color mixing easy to understand and put into action—even for the beginner! #30658/$27.99/128 pages/230 color, 15 b&w illus.

Realistic Oil Painting Techniques—Discover how to create realistic, classically styled paintings that seem to glow from within. You'll find instructions on drawing methods for perspective and proportion, using halftones and highlights, seeing natural colors and recreating them, altering a painting's atmosphere and much more! #30654/$27.99/144 pages/126 color illus.

Capturing Radiant Colors in Oils—Revitalize your paintings with light and color! Exercises will help you see color relationships and hands-on demonstrations will let you practice what you've learned. #30607/$27.99/144 pages/222 color illus.

Welcome To My Studio: Adventures in Oil Painting With Helen Van Wyk—Share in Helen Van Wyk's masterful advice on the principles and techniques of oil painting. Following her paintings and sketches, you'll learn the background's effect on color, how to paint glass, the three basic paint applications and much more! #30594/ $27.99/128 pages/146 color, 90 b&w illus.

Timeless Techniques for Better Oil Paintings—You'll paint more beautifully with a better understanding of composition, value, color temperature, edge quality and drawing. Colorful illustrations let you explore the painting process from conception to completion. #30553/$27.99/144 pages/175 color, 25 b&w illus.

Basic Oil Painting Techniques—Learn how to give your artwork the incredible radiance and depth of color that oil painting offers. Here, six outstanding artists share their techniques for using this versatile medium. #30477/$16.99/128 pages/ 150+ color illus./paperback